MW00562373

IMAGES
of America

VICKSBURG
NATIONAL CEMETERY

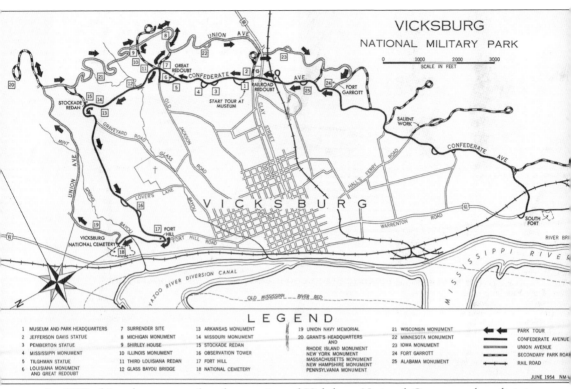

VICKSBURG
NATIONAL MILITARY PARK

SCALE IN FEET
0 1000 2000 3000

LEGEND

1 MUSEUM AND PARK HEADQUARTERS	7 SURRENDER SITE	13 ARKANSAS MONUMENT	19 UNION NAVY MEMORIAL	21 WISCONSIN MONUMENT	PARK TOUR
2 JEFFERSON DAVIS STATUE	8 MICHIGAN MONUMENT	14 MISSOURI MONUMENT	20 GRANT'S HEADQUARTERS	22 MINNESOTA MONUMENT	CONFEDERATE AVENUE
3 PEMBERTON STATUE	9 SHIRLEY HOUSE	15 STOCKADE REDAN	AND	23 IOWA MONUMENT	UNION AVENUE
4 MISSISSIPPI MONUMENT	10 ILLINOIS MONUMENT	16 OBSERVATION TOWER	RHODE ISLAND MONUMENT NEW YORK MONUMENT	24 FORT GARROTT	SECONDARY PARK ROAD
5 TILGHMAN STATUE	11 THIRD LOUISIANA REDAN	17 FORT HILL	MASSACHUSETTS MONUMENT NEW HAMPSHIRE MONUMENT	25 ALABAMA MONUMENT	RAIL ROAD
6 LOUISIANA MONUMENT AND GREAT REDOUBT	12 GLASS BAYOU BRIDGE	18 NATIONAL CEMETERY	PENNSYLVANIA MONUMENT		

JUNE 1954 NM-V

In 1899, thirty-three years after the creation of Vicksburg National Cemetery, the adjoining Vicksburg National Military Park was established. This map presents an overall perspective of troop locations at Vicksburg as memorialized through the emplacement of state monuments in the park. Located approximately one and one-half miles north of the city, the cemetery (No. 18) is depicted on this 1954 map. (Courtesy of the National Park Service.)

ON THE COVER: Erected in 1879, this McClellan-style gateway, named for Gen. George B. McClellan, afforded entrance into one of the nation's first national cemeteries and was built at a cost of $7,000. The attic story features the inscription "Here Rest In Peace 16,600 Citizens Who Died For Their Country In the Years 1861–1865." (Courtesy of the Library of Congress.)

IMAGES
of America

VICKSBURG
NATIONAL CEMETERY

Elizabeth Hoxie Joyner

ARCADIA
PUBLISHING

Copyright © 2024 by Elizabeth Hoxie Joyner
ISBN 978-1-4671-6108-4

Published by Arcadia Publishing
Charleston, South Carolina

Printed in the United States of America

Library of Congress Control Number: 2024932441

For all general information, please contact Arcadia Publishing:
Telephone 843-853-2070
Fax 843-853-0044
E-mail sales@arcadiapublishing.com

Visit us on the Internet at www.arcadiapublishing.com

*Dedicated to past, present, and future service members of
all branches of our military for their dedication, unwavering
bravery, and unselfish service to our country*

CONTENTS

Acknowledgments 6

Introduction 7

1. Establishment of Vicksburg National Cemetery:
 Creation of a Lasting Tribute 9

2. The Drum Beat and the Cannon Roared:
 Mexican War and Civil War Soldiers 21

3 Duty, Honor, Country:
 Spanish-American War through Korean War 69

4. Remembered with Honor and Respect:
 Vietnam War, 1955–1975 107

5. Vicksburg National Cemetery Superintendents:
 Guardians of This Hallowed Ground 113

Burial Index 125

ACKNOWLEDGMENTS

I thank my husband, Raymond, for always encouraging me and my son, Travis, for research assistance and help in locating graves. I love you both.

My deepest gratitude is extended to the following, for without their help, this book would not have been possible: Terrence J. Winschel, retired Vicksburg National Military Park historian; George Bolm and Jordan Rushing, Old Court House Museum, Vicksburg; Jeff T. Giambrone, Mississippi Department of Archives and History, Jackson; Thomas Lofton, and Dusty Mercier, Mississippi Armed Forces Museum, Hattiesburg; Linda Goff, sister of Henry Lee Keen; Linda Loviza, descendant of Alexander Henry; Susan Jorgensen Carey, great-great-granddaughter of Edward Lewis; Sylvester Jackson, Maxwell Air Force Base, Alabama; LaVone Kay, Commemorative Air Force Rise Above Squadron, Minnesota; Tonga Vinson, Neel-Schaffer Inc., Vicksburg; Sherry Grimsley, Southern Heritage Air Foundation, Louisiana; Amanda Fallis, New Orleans Public Library; Carmela Furio and Diane Ray, University of Iowa Libraries; Steve Gregory, Fort Huachuca Museum, Arizona; Sarah Junod, Scott County, Minnesota, Historical Society; Raven Jones, Cushing Memorial Library and Archives, Texas A&M; and Melissa Ladner, Mississippi Gulf Coast Community College, Perkinston.

The images in this volume appear courtesy of the Library of Congress (LOC), Mississippi Gulf Coast Community College (GCCC), Mississippi State University (MSU), National Archives and Records Administration (NARA), Naval History and Heritage Command (NHHC), National Park Service, and Vicksburg National Military Park (VNMP).

INTRODUCTION

During the Vicksburg campaign and siege, which occurred from May 18 to July 4, 1863, troops were initially buried in shallow, hurriedly dug graves wherever they had died in battle or succumbed to disease. When the Civil War ended in 1865, cemeteries were needed all over the country in order to honor and properly bury those who had paid the ultimate sacrifice.

On July 17, 1862, Congress passed legislation that laid the groundwork for the eventual establishment of Vicksburg National Cemetery, which is one of 21 national cemeteries, along with Natchez National Cemetery, established in 1866. Initially, only Union Civil War dead were entitled to burial in this hallowed ground. However, subsequent legislation following the Spanish-American War permitted veterans of later wars the honor of being buried within national cemeteries.

Originally it was recommended by Lt. Col. Gilbert L. Parker, assistant quartermaster at Vicksburg, to acquire 75–100 acres close to the Surrender Interview Site. The Surrender Interview Monument had been erected on the spot where the historic oak tree once stood under which Union major general Ulysses S. Grant and Confederate lieutenant general John C. Pemberton met to discuss terms of surrender on July 3, 1863. The resulting devastation and war-torn terrain around Vicksburg made it very difficult to find an appropriate location. A section of land was selected that ran along Warrenton Road, approximately two miles south of Vicksburg. The property was owned by Abram B. Reading, who wanted $30,000 for 56 acres.

The first land selection was too prohibitive a price, so the US government purchased a tract of land that contained slightly less than 40 acres for the cemetery located at the western edge of the city's defensive line. The land was deeded to the US government in August 1866 by Alney H. Jaynes and his wife, Cynthia, for $9,000. (In subsequent years, the cemetery was expanded, and today, it encompasses 116 acres, of which only the original 40 acres contain burials.)

Union remains were retrieved from 50 miles around Vicksburg, from the west side of the Mississippi at a point opposite Grand Gulf, Mississippi, to the Arkansas line and on the east side from Rodney, Mississippi, to opposite the Arkansas line, including Rodney and Grand Gulf. When located, many of the graves were in very poor condition, and in many cases, remains were recovered without any form of identification. As a result, over 75 percent of the dead could not be identified.

The cemetery serves as the final resting place for 17,077 Civil War soldiers and sailors, of which 12,909 are unknown. The names of the identified were taken from the original cemetery ledgers. All identified graves have headstones with their name and grave number, while the unknown are marked with small square blocks containing only a grave number. Approximately 40 percent of the burials are believed to be of the US Colored Troops, many of whom served at Vicksburg as occupation forces following the siege.

Two Confederate burials were later discovered in Section B. Pvt. Reuben White of the 19th Texas Infantry Regiment is buried in Grave No. 2637, and Sgt. Charles B. Brantley of the

12th Arkansas Sharpshooter Battalion is buried in Grave No. 2673. Most recently, it has been discovered that two more Confederates were also mistakenly buried in the cemetery. Pvt. Robert T. Skelton, who served with the 37th Mississippi Volunteers, Company D, is buried in Section O, Grave No. 3819, and Lt. Numa Arrieux of the 26th Louisiana, Company C, is buried in Section O, Grave No. 7101. Another recent discovery may lead to the marking of a previously unknown soldier's grave. It is thought that the unknown marker in Section O, Grave No. 3524, is the grave of John G. Seitz, who served with the 45th Pennsylvania Infantry, as he was originally buried at Milldale (in present-day Redwood, Mississippi) alongside the two soldiers who are buried on either side of him now.

An additional 1,280 burials are occupied by soldiers and sailors who fought in the Indian Wars, the Spanish-American War, World War I, World War II, and the Korean War. Also included is a memorial section to honor those who so bravely fought in the Vietnam War. Later, legislation was amended to allow the burial of wives, children, and government workers. As a result, there are 27 government workers interred.

Vicksburg National Cemetery was administered by the War Department from 1866 to 1933, when it was transferred to the National Park Service, Department of Interior, at which time it was incorporated into Vicksburg National Military Park. Upon the retirement of cemetery superintendent Randolph G. Anderson on March 24, 1947, no one was appointed to succeed him, and responsibility for the cemetery was delegated to then park superintendent James R. McConaghie. Today, the cemetery is one of 14 national cemeteries managed by the National Park Service.

The cemetery was to be a place of serenity and beauty to honor the courageous men and women who sacrificed their all, and as such, it was important to fill the area with beautiful trees, shrubs, and plants. Pres. Andrew Johnson donated 100 slips of weeping willows to the cemetery. Other varieties of trees represented include the Japanese magnolia, German linden, Spanish oak, and dogwood. In order to care for all of the greenery, a gardener was employed. Henry Winnerwisser, who had been a gardener at the White House in Washington, DC, began working at Vicksburg National Cemetery on January 4, 1895, and was employed as the cemetery's gardener until March 14, 1898. For 28 years, William Murphy was the cemetery's gardener, retiring at 70 years of age in 1933.

Other important additions made during the cemetery's development include the erection of a wooden flagstaff in the early 1880s in Section O, on the highest point in the cemetery, on which to raise and lower our nation's flag. In 1906, the wooden flagstaff was replaced at a cost of $650 with a 100-foot iron flagstaff that stands today.

Shortly after the cemetery's establishment, a belfry was built for a bell that was used to inform cemetery employees working in different parts of the cemetery of the end of their shift. On May 9, 1927, during a severe storm, the 25-foot structure was blown down. Supt. William E. Sullivan recommended that the bell tower be rebuilt. His recommendation was deemed unnecessary, and so the bell remains in the cemetery unsheltered and is located adjacent to the flagpole. Today, the bell is utilized during various commemorative events.

Visitors from all walks of life and all 50 states, as well as international visitors, travel to Vicksburg National Cemetery, endeavoring to locate graves of ancestors and explore the adjoining battlefield where so many lost their lives.

One

ESTABLISHMENT OF VICKSBURG NATIONAL CEMETERY

CREATION OF A LASTING TRIBUTE

Walking through the ornate black iron gates, row upon row of gleaming white headstones are a grim reminder of the fierce fighting that once took place on this hallowed ground held by the extreme right of Maj. Gen. William T. Sherman's XV Army Corps.

Following the establishment of the cemetery and preparation of the grounds, teams of workmen spread out over a 50-mile radius in order to begin the gruesome task of removing and retrieving the Union dead from their hastily dug graves to be transported and reinterred at Vicksburg National Cemetery. Priority was given to removing the bodies that had been buried along the river banks and levees. The first burials were interred in 1867. Unfortunately, due to the passage of time and wartime conditions that prevented some of the burials from being properly marked, not all had forms of identification on their person, and some graves that had previously been marked were missing their markers, thus the large number of unknowns.

Small square marble blocks bearing grave numbers indicate the graves of the unknown, while upright marble headstones identify the known. Many of the government-issued headstones were supplied by Columbus Marble Works, in existence since 1846 and located in Columbus, Mississippi. Due to space constraints, the cemetery was closed to burials, other than those plots reserved, on May 1, 1961.

Today, the National Park Service, Department of Interior, administers 14 national cemeteries, including Andersonville, Fort Donelson, Chalmette, Petersburg, Gettysburg, Shiloh, and Vicksburg.

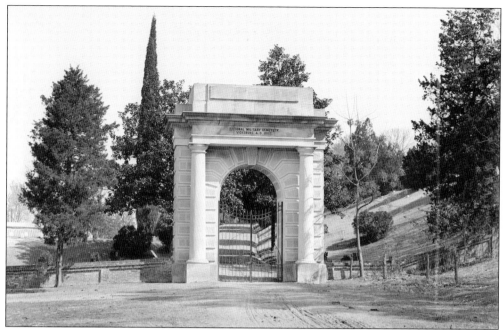

Erected in 1879 to serve as the entrance to Vicksburg National Cemetery, this gate is located on the southwestern edge of the cemetery. According to the 1893 site plan, the 36-foot-tall gate is constructed of Alatawa limestone, modeled after a triumphal arch, and features two 17-foot-tall solid stone columns joined by an arch and topped with an entablature and attic story. (Courtesy of LOC.)

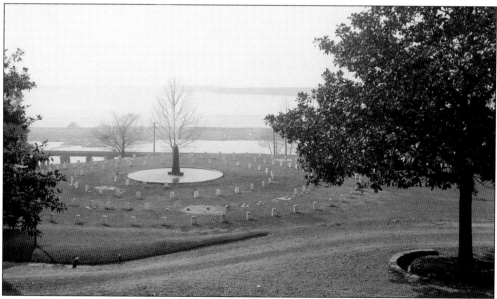

An upturned 10-inch Columbiad was converted into a fountain by placing the gun in a concrete basin. Through the utilization of gravitational force, water from Mint Spring Bayou was propelled through its bore, spraying several feet upward. The fountain was prominently featured within Officer's Circle, located near what was then the main entrance into the cemetery. Today, although the cannon remains, the fountain is unfunctional. (Courtesy of LOC.)

In the early years, the cemetery contained its own nursery, which was very beneficial to early landscaping efforts. During the 1870s, approximately 3,600 trees were planted, and among them were magnolias, cedars, and holly, as well as other evergreen trees and shrubs. Gravel was dispersed throughout the drives to create safer roads to accommodate the many visitors to the site. (Courtesy of the photograph collection of the Old Court House Museum.)

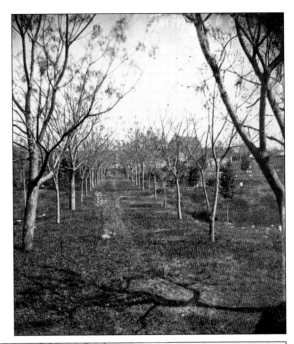

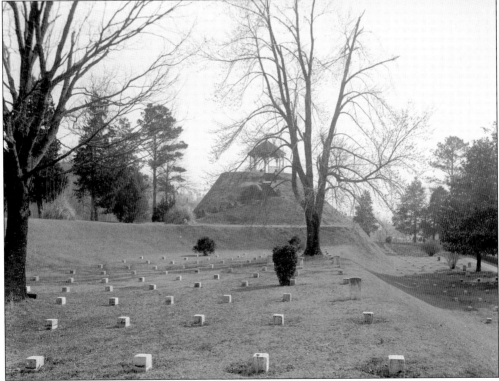

Sitting atop the Indian Mound is the original wooden arbor that remained in this location for 55 years. Over the years, the wooden arbor became almost completely rotted, so it was replaced in 1931 by the brick rest pavilion, which still stands today, providing a peaceful respite for visitors. (Courtesy of LOC.)

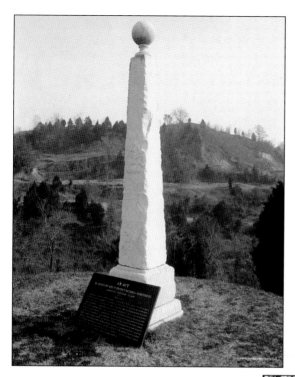

In 1868, the Surrender Interview Monument, also referred to as the Grant/Pemberton Marker, was relocated to the Indian Mound to prevent further loss of the memorial by souvenir hunters seeking a memento of the historic moment when Grant and Pemberton met to discuss surrender. In August 1940, it was moved back to the Surrender Interview Site. Today, it is displayed inside the Visitor Center. (Courtesy of LOC.)

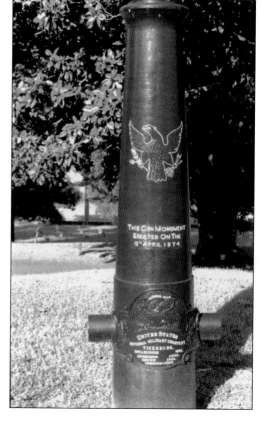

Cast in 1827 at West Point Foundry and one of three cannons situated within the cemetery, this 24-pounder smoothbore bears the imprint of an eagle. Inscribed on the gun is the following: "This Gun Monument / Erected On The / 13th April 1874. E Pluribus Unum / United States / National Military Cemetery / Vicksburg. / Established 1865." It also lists the number of known and unknown burials. (Courtesy of the author.)

Maj. Gen. William Tecumseh Sherman, whose middle name was derived from an admired Indian chief, was subsequently nicknamed "Cump," a nickname that stayed with him all of his life. An 1840 West Point graduate, Sherman served as commander of the XV Army Corps during the Vicksburg campaign and siege. (Courtesy of LOC.)

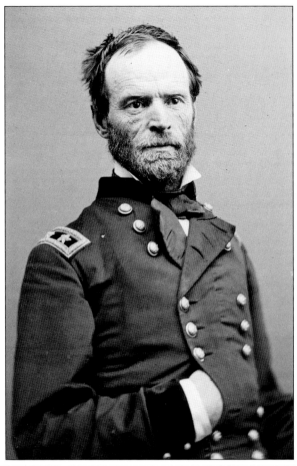

Today, the tranquil and solemn grounds of the cemetery are not reflective of the events that transpired here in 1863. During the Vicksburg campaign and siege, the grounds of what is now Vicksburg National Cemetery were garrisoned by the extreme right of Maj. Gen. William Tecumseh Sherman's XV Army Corps, as depicted in this sketch from *Harper's Pictorial History of the Civil War*. (Courtesy of the author.)

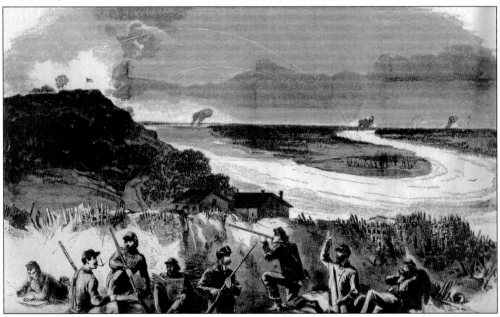

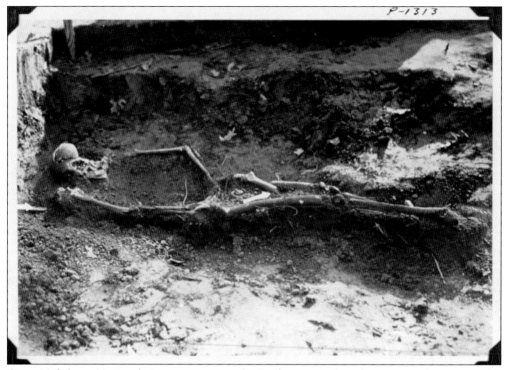

Once Vicksburg National Cemetery was authorized, teams of workmen spread out over the countryside to recover the graves of Union soldiers and sailors. Remains were retrieved from a 50-mile radius surrounding Vicksburg including Louisiana and Arkansas. By the end of August 1868, a total of 15,595 had been interred within the cemetery. These recovered skeletal remains were unearthed by Civilian Conservation Corps workers on January 16, 1936. (Courtesy of VNMP.)

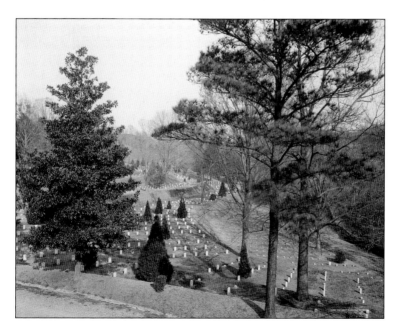

During the 1930s, continued landscaping of the cemetery included the planting of over 60 species of trees by the Civilian Conservation Corps as an erosion control method. Proper care of the beautiful and rare specimens was vital to the beauty of the grounds. Perhaps the rarest is the ginkgo tree, the oldest known tree of civilization. (Courtesy of LOC.)

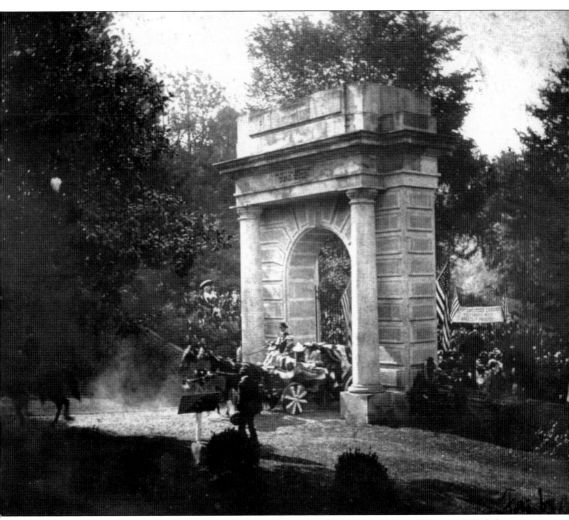

Arriving at the cemetery in a horse-drawn carriage provided by Fisher Funeral Home of Vicksburg, the second president to visit Vicksburg National Cemetery was Pres. William McKinley at 8:18 a.m. on May 1, 1901. The president was accompanied by First Lady Ida Saxton McKinley, Secretary of State John Hay and his wife, Postmaster General Charles E. Smith, and Secretaries Ethan Hitchcock, James Wilson, and George Cortelyou. During his brief visit, he addressed the crowd that had gathered outside the flag-adorned entrance gate. Following his address, he and members of his party drove through the winding roads of the cemetery on their way to the courthouse. Members of the crowd held a sign welcoming the president. McKinley was one of three presidents to visit the consecrated ground. Pres. Ulysses S. Grant was the first to visit. Pres. Theodore Roosevelt, who visited in 1907, was the last president to pay a visit to the cemetery. (Courtesy of the photograph collection of the Old Court House Museum.)

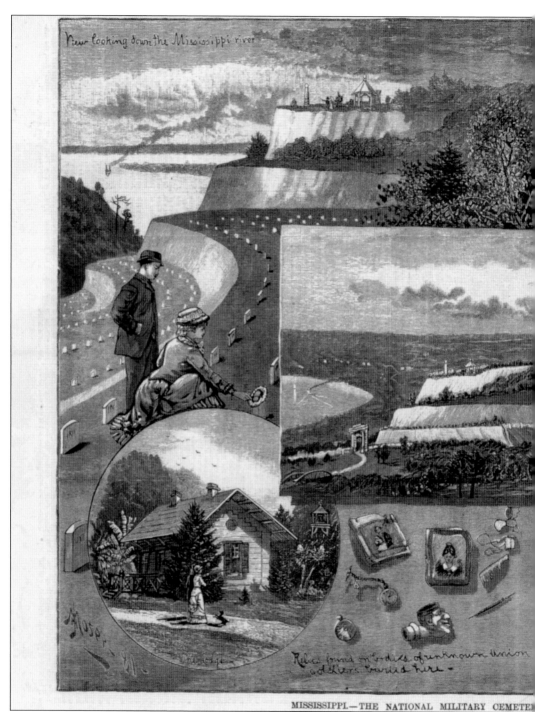

Depicted scenes in this 1881 issue of *Frank Leslie's Illustrated Newspaper*, clockwise from left, include a man and woman decorating graves in preparation for Decoration Day; the terraced landscape; men looking across the Mississippi River from high on the hilltops above; the headstone of Lt. Hiram Harting Benner, who served with the 18th Illinois, Company C, and survived the Civil War only to succumb to yellow fever in 1878 while bringing medical supplies to victims along the

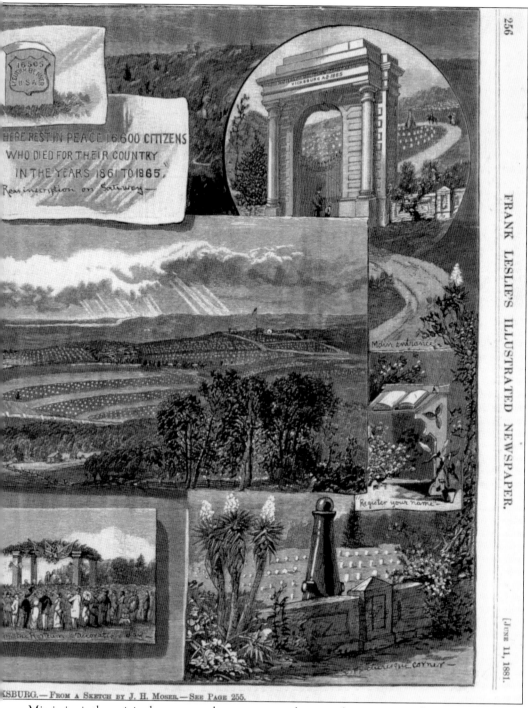

FRANK LESLIE'S ILLUSTRATED NEWSPAPER.

[JUNE 11, 1881.

...KSBURG.—FROM A SKETCH BY J. H. MOSER.—SEE PAGE 255.

Mississippi; the original ornamental cemetery gate bearing the inscription "Here Rest In Peace 16,600 Citizens Who Died For Their Country In The Years 1861 To 1865"; the curving carriage drives; the cemetery ledger for recording the names and localities of cemetery visitors; one of the displayed cannons; the brick enclosure; the rostrum used to accommodate speakers; personal effects of interments; and the superintendent's lodge. (Courtesy of the author.)

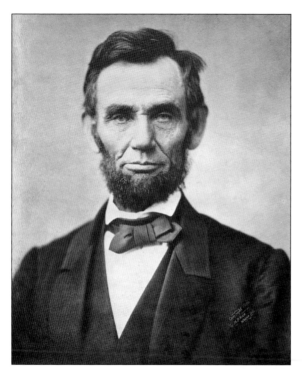

This is a portrait of the 16th president of the United States, Abraham Lincoln, as photographed by Alexander Gardner on November 8, 1863. The portrait was made 11 days prior to him delivering the Gettysburg Address on November 19, 1863, at the dedication of Soldiers' National Cemetery, later renamed Gettysburg National Cemetery. (Courtesy of LOC.)

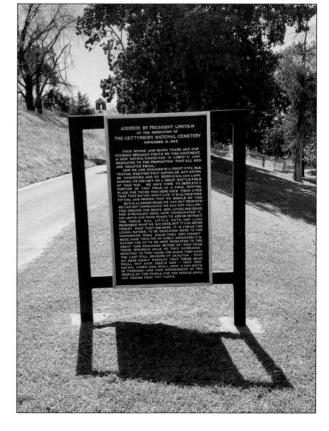

Positioned approximately halfway through the cemetery is the Gettysburg Address plaque, which was placed in national cemeteries in 1909 in honor of the centennial of Abraham Lincoln's birth in 1809. The commemorative cast-iron plaque is painted black with silver lettering. The plaque stands five feet tall by three feet wide and is affixed to poles. (Courtesy of the author.)

Cast-iron tablets featuring stanzas from the poem "Bivouac of the Dead," written by Theodore O'Hara, can be found throughout the cemetery. A Kentucky native, O'Hara wrote the poem to honor his fellow Kentuckian soldiers who died in the Mexican-American War. The poem was so compelling that it stirred the emotions of a patriotic nation and was first used at Arlington. (Courtesy of the author.)

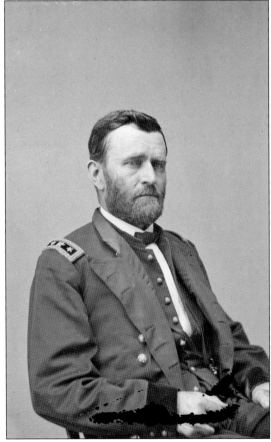

Maj. Gen. Ulysses S. Grant served as commander of the Union Army of the Tennessee during the Vicksburg campaign and siege. Elected as the nation's 18th president, Grant served two terms. On April 12, 1880, the former president made a return trip to Vicksburg and the cemetery. During his visit, he complimented cemetery superintendent John Trindle on the "Lovely appearance of the grounds." (Courtesy of LOC.)

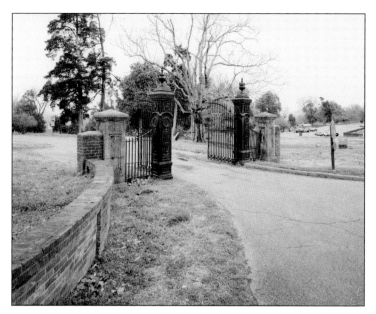

Today, ornamental iron gates located across from the USS *Cairo* Gunboat and Museum provide entry. Identical gates can be found at Shiloh, Chalmette, Alexandria, and other national cemeteries. When closed to vehicular traffic, visitors enter through either side of the main gate in order to enjoy the beauty and solemnity of the area on foot. A low brick wall constructed in 1874 encloses the cemetery. (Courtesy of LOC.)

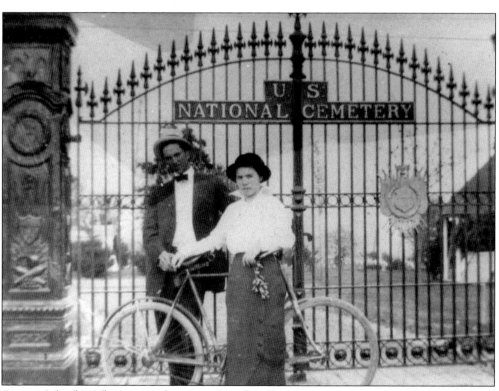

George Otha "G.O." Carter and Octavia "Tava" Jordan pose for a picture in front of the newly installed gates of Shiloh National Cemetery, which are identical to the gates at Vicksburg National Cemetery. The couple married in 1914 and became caretakers of Shiloh National Military Park. Cycling continues to be a favorite pastime for many visitors to the nation's national parks. (Courtesy of descendants of the Carter/Jordan family.)

Two

The Drum Beat and the Cannon Roared

Mexican War and Civil War Soldiers

Vicksburg National Cemetery is the nation's largest national cemetery in terms of Civil War burials, but many who fought in the Civil War also fought in the earlier Mexican-American War, which occurred during the years 1846 to 1848. When the cemetery was initially created in 1866, it was to be for Civil War burials only. However, subsequent legislation approved interments from other wars as well as for wives and dependent children. The first burials occurred in 1867.

It has been said that the Civil War was a "young man's war." This statement is quite evident as one reads the details provided for each burial; a constant is that most are young men. There are approximately 17,000 Civil War burials in Vicksburg National Cemetery. This chapter focuses on those veterans, their stories, and their sacrifices illustrated through images, documents, and wartime sketches.

Of the approximately 620,000 soldiers who died during the Civil War, two-thirds died from disease. Vicksburg was no different, in that many who are interred here also died as a result of diseases such as dysentery, yellow fever, typhoid fever, and malaria. The heat, humidity, mosquitoes, poor diet, and unclean conditions were all contributing factors.

The majority of the headstones are government-issued, whether known or unknown, but not all, as some were placed by families who traveled hundreds of miles to see that their loved ones' grave was properly marked, like the family of Cpl. Isaac S. Brown.

It was previously thought that Dr. James Bog Slade was the sole Mexican-American War veteran to be interred here, but there are a number of veterans interred who fought in that war as well as the Civil War.

Bvt. Brig. Gen. Embury Durfee Osband, US Colored Cavalry, is the highest-ranking soldier interred.

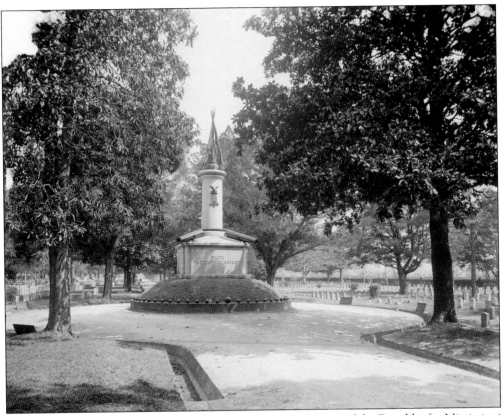

Former Vicksburg alderman, adjutant general of the Grand Army of the Republic for Mississippi and Louisiana, and a charter member of Vicksburg's St. Mary's Episcopal Church, Pvt. Nelson A. Anderson served in the 2nd US Colored Light Artillery, Company D. He died in May 1906. The Grand Army of the Republic (GAR) Memorial erected within Chalmette National Cemetery is one of the few GAR memorials in the South. (Courtesy of LOC.)

Lt. Numa Arrieux, serving with the 26th Louisiana Infantry, Company C, is one of at least four known Confederates to have been accidentally reinterred in Vicksburg National Cemetery. Arrieux was killed at Vicksburg early in the morning during the second assault on May 22, 1863. Etched on his headstone is an acorn, which symbolizes strength, power, independence, triumph, and perseverance. (Courtesy of the author.)

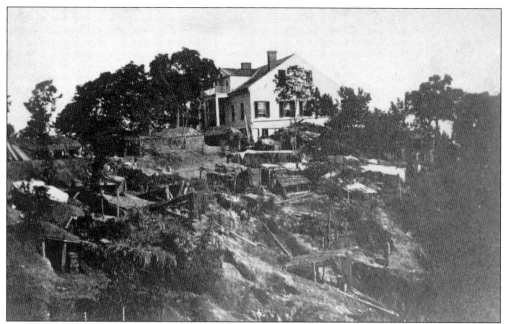

Described in the June 25, 1863 edition of the *Sabbath Recorder* as having been "much loved by the boys in his company," Pvt. Jesse Babcock, the ninth child of Joel C. and Anna Greene Babcock, served in the 20th Ohio Infantry, Company K. On May 24, 1863, while resting in his tent, Babcock was killed by a Confederate sharpshooter, and he was originally buried 200 yards northeast of the Shirley House. He was only 20 years old. (Courtesy of LOC.)

At 39, George Henry Bockus (spelled "Backus" on his headstone) enlisted as a private in the 45th Pennsylvania Volunteer Infantry, Company G, with his brother, Andrew. Born in St. Johnsonville, New York, on September 7, 1822, he married Jane Eliza Rockwell at 17. The couple farmed in Charleston, Pennsylvania. George died of dysentery on August 1, 1863, while in the field hospital at Milldale, Mississippi. (Courtesy of Alfred Pope.)

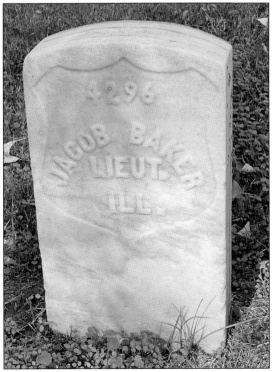

Pvt. Cyrus H. Bair served in the 11th Indiana, Company G, during the Civil War. He died on May 19, 1863, and was originally buried in four pits in the vicinity of the ruins of Col. Sydney Champion's old residence, Champion Plantation in Hinds County, Mississippi. The Coker House, seen here, was used as a field hospital for wounded Union and Confederate soldiers during the Battle of Champion Hill. (Courtesy of LOC.)

Jacob Baker, born in Ohio in 1826, married Emily Monroe, a Kentuckian born in 1835. The two had a daughter born in 1859 named Etta Loretta Baker. Jacob's prewar occupation was as a farmer and carpenter before enlisting in the Army in Wayne County, Illinois. Second Lieutenant Baker served in the 5th Illinois Cavalry, Company M. He died on August 5, 1864, at 38 to 39 years old. (Courtesy of the author.)

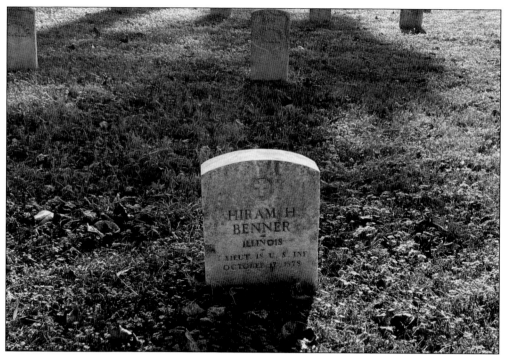

Born in 1844 in Strasburg, Pennsylvania, Lt. Hiram Harting Benner served with the 18th Illinois, Company C, during the Civil War. He married Della Gates Benner on November 19, 1866, in Kane, Illinois. The couple had four children and in 1870 lived in Georgia. During the 1878 yellow fever epidemic, Benner volunteered to bring medical supplies to people along the lower Mississippi. He contracted the disease, dying on October 17, 1878. Della drew his pension in August 1880. Five years later, in the December 29, 1885, edition of the *New York Times*, it was reported that Della Benner was appointed postmaster of the village of Rodger's Park, in the township of Evanston, where she had lived since her husband's passing. She lived to be 90, passing on March 19, 1937, and is buried with her husband. (Both, courtesy of the author.)

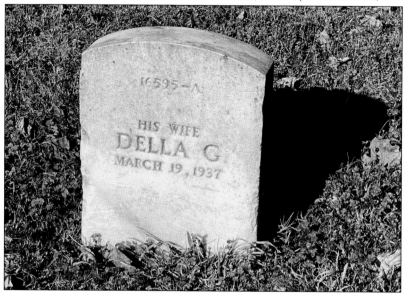

Francis O. Blake drowned on June 25, 1863, while serving on board the USS *General Price* as acting master's mate in the Union navy. It is thought that the above unknown marker within Vicksburg National Cemetery may be that of Francis Blake. The vessel served the Confederacy as the ram CSS *General Sterling Price* from 1861 to 1862 before being sunk at the Battle of Memphis on June 6, 1862. The vessel was raised and repaired for service in the Union navy. She was commissioned for US Navy service in March 1863 as USS *General Price*. (Above, courtesy of the author; below, courtesy of NHHC.)

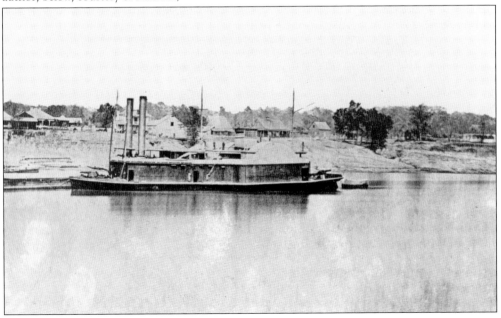

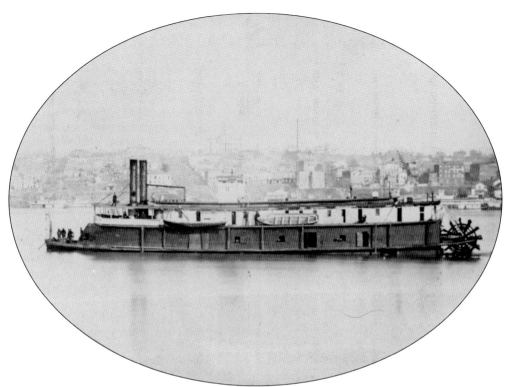

Philip Blanch served as a landsman aboard the USS *Prairie Bird*, pictured above. Barely visible, towering above the city's skyline is today's Old Court House Museum. Through an undetermined malady, Blanch was transferred from the *Prairie Bird* to the hospital ship USS *Red Rover* (below), photographed by Acting Assistant Surgeon George Holmes Bixby, MD, chief medical officer aboard the USS *Red Rover*. On July 27, 1865, Blanch was discharged as a Navy invalid. Following the war, according to the 1880 federal census, he and his wife, Frances (nicknamed "Fannie"), were living in Vicksburg, and he was working as a farmer while she was a housewife. Blanch died on February 1, 1896. (Both, courtesy of NHHC.)

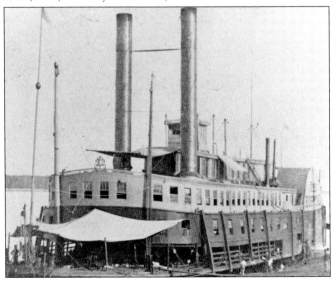

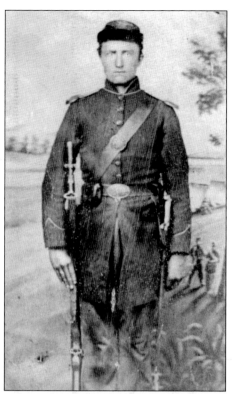

Pvt. Ernst August Boessling emigrated from Germany in 1854 at eight years old. Boessling's parents granted permission for his enlistment in the 5th Minnesota, Company D, in a letter dated February 1862. He survived the siege only to die of disease on September 10, 1863, at Camp Sherman, Mississippi. A cenotaph was erected in his memory by his family at Oakwood Cemetery in Austin, Minnesota. (Courtesy of Scott County Historical Society.)

Born in 1841 in Fayette, Jefferson County, Mississippi, Napoleon Bonaparte served with the 5th Regiment US Colored Heavy Artillery, Company K, formerly the 9th Louisiana Infantry (African Descent), which fought in the Battle of Milliken's Bend. This regiment organized at Vicksburg and also served in garrison duty at Vicksburg until May 1866. Bonaparte was between 55 and 56 years old when he died on February 20, 1897. (Courtesy of the author.)

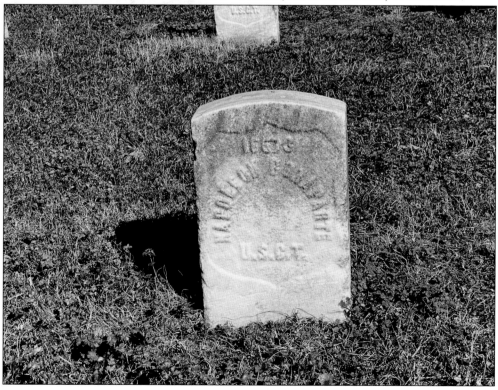

Born in 1817, Pvt. George M. Boyer (spelled "Boyes" on his headstone) served in both the Mexican-American and Civil Wars. He was first married to Irena Lombard, and they had six children. On October 25, 1861, he married Ruth M. Matthews. Despite the name on the headstone as "Boyes," he is not in the cemetery database by that name but as "Boyer," though he is on the original cemetery sheets as "Boyes." (Courtesy of the author.)

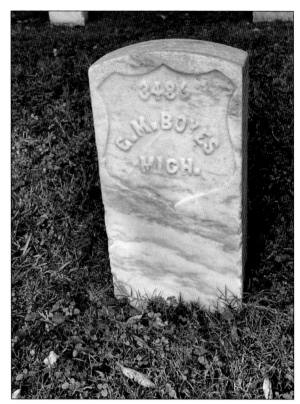

Pvt. George M. Boyer served in the 27th Michigan Volunteer Infantry, Companies G and H, during the Civil War. He was a blacksmith by trade prior to the war. Boyer died on July 2, 1863. He was 45–46 years old at his death and was originally buried at Milldale (present-day Redwood), Mississippi. Five years after his death, Ruth M. Boyer remarried. She later filed for George's pension. (Courtesy of NARA.)

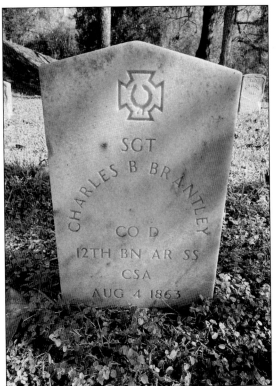

Sgt. Charles B. Brantley, son of Lewis and Mary Brantley of Tennessee, is one of at least four known Confederates accidentally interred in the cemetery. When his father died in 1856, the family moved to Arkansas. During the Civil War, Brantley served with the Department of Mississippi and East Louisiana, 2nd Brigade, 12th Battalion Arkansas (Rapley's) Sharpshooters, Company D. He died in Madison Parish, Louisiana, on August 4, 1863. (Courtesy of the author.)

Cpl. William Brewer served with the 16th Wisconsin Volunteers, Company I, and in February 1863 was involved in excavating the Lake Providence canal to allow passage of transports via the Baxter and Macon Bayous into the Tensas, Ouachita, and Red Rivers as an alternate route to reach Vicksburg. Brewer died while at Lake Providence, Louisiana, and was originally buried there before being reinterred within Vicksburg National Cemetery. (Courtesy of the author.)

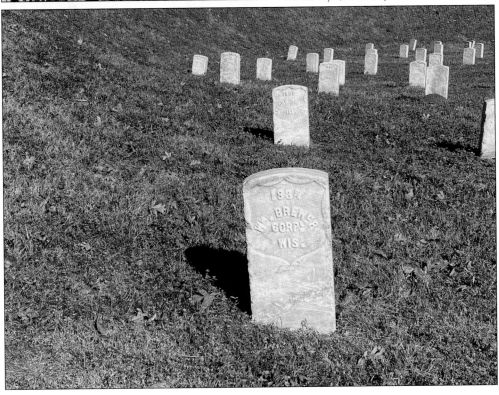

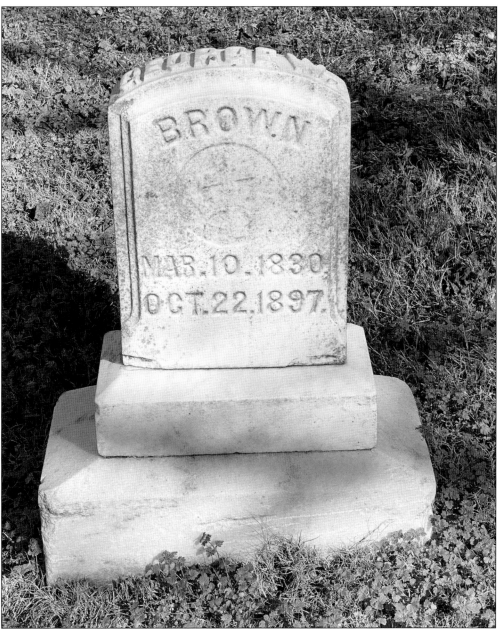

Standing out amidst the many government-issued headstones is the private marker for Cpl. George W. Brown, which is embellished with an encircled cross and topped with letters spelling "George W." Born in Mississippi on March 10, 1830, Brown served in the 47th US Colored Infantry, Company B, originally organized as the 8th Louisiana Infantry Volunteers Regiment (African Descent). This regiment saw duty at Lake Providence and Milliken's Bend, Louisiana, before being transferred to Vicksburg. On March 11, 1864, the regiment became the 47th US Colored Infantry. Brown was married to Minerva Brown, and the couple had a son named Peter, who was born in 1870. Following the war, Brown's occupation was as a drayman, and Minerva kept house. He died on October 22, 1897, and is buried with his wife, who passed on November 24, 1917. (Courtesy of the author.)

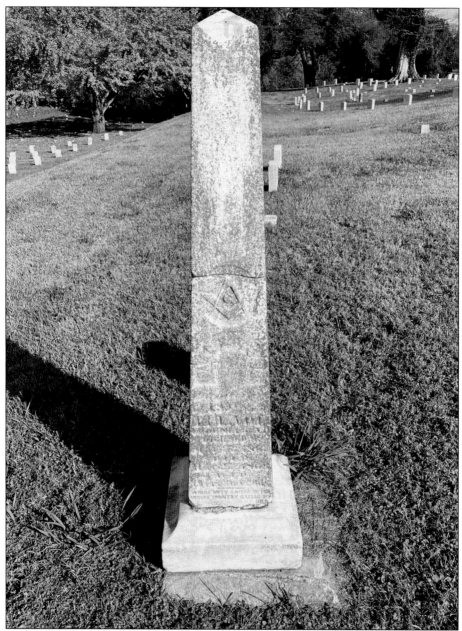

The marker's inscription, "Where Duty Called He Led Where Country Called He Died," sums up the bravery exhibited on the Vicksburg battlefield by Cpl. Isaac S. Brown while attempting to rescue a fellow Mason. Born on February 7, 1810, in Daviess County, Kentucky, Cpl. Isaac S. Brown married Catherine E. Hay on February 7, 1832. During the Civil War, Brown served in the 99th Regiment Illinois Volunteer, Company I, as a wagon master. Brown was mortally wounded in the rescue attempt of a fellow Mason on May 22, 1863, when he was shot through the thumb after the bullet passed through his comrade. He contracted blood poisoning and died on May 27, 1863. The obelisk-shaped monument also features the Masonic emblem. In March 1869, Catherine and their son, William, made the trip to Vicksburg to see that their loved one's grave was properly marked. (Courtesy of the author.)

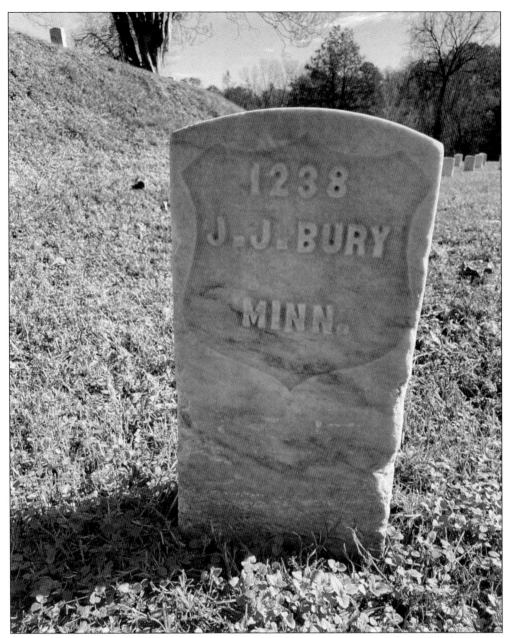

Born in Switzerland in 1843, Pvt. John J. Bury enlisted in the Union army along with three other Bury men (David B., Frederick, and Jacob John) on December 19, 1861, in the 5th Minnesota Infantry, Company A. The majority of those enlisting were from Goodhue County, Minnesota. This regiment mustered into federal service at Fort Snelling, Minnesota, on March 15, 1862, and served in the western theater of the war. The 5th Minnesota was garrisoned in Vicksburg on July 4, 1863, to witness the surrender. Other notable battles this unit was involved in besides Vicksburg included: Farmington, Mississippi, on May 28, 1862; Iuka, Mississippi, on September 19, 1862; and Corinth, Mississippi, on October 4, 1862. Private Bury died on September 21, 1863, while at Vicksburg, according to the *Roll of Honor, Issue 24*. He was between 19 and 20 years old. (Courtesy of the author.)

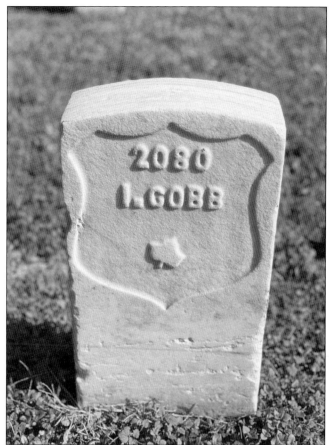

Isaac Washington Cobb was born about 1813 in Edgefield, South Carolina, to Jeremiah Cobb and Elizabeth Corley. He married Nancy Coolhorn in 1838, and they had two sons and four daughters. His prewar occupation was as a farmer. His first wife died in 1849. One year later, on February 24, 1850, he married Nancy Campbell, and they had seven children. According to the 1850 and 1860 censuses, he was living in Pontotoc, Mississippi. During the Civil War, he served aboard the USS *Cincinnati* (pictured below). He died on March 13, 1863, at the age of 51 and was buried in Vicksburg National Cemetery. (Left, courtesy of the author; below, courtesy of NHHC.)

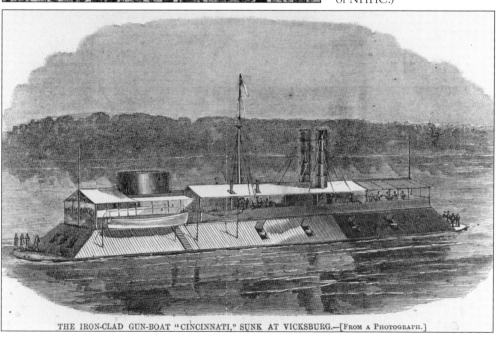

THE IRON-CLAD GUN-BOAT "CINCINNATI," SUNK AT VICKSBURG.—[FROM A PHOTOGRAPH.]

Capt. Edward J. Cook served in the 95th Illinois Infantry, Company D, and sustained wounds in the May 22, 1863, assault at Vicksburg resulting in his death on June 11, 1863. Cook was a widower and father of four minor children. When he died, guardianship of the children was assumed by the executor of his estate, Richard P. Clark. He filed for pension to be received by the minor children, named William H. Cook (born February 24, 1845), Edward John Cook (July 11, 1847), Emily Louisa Cook (October 15, 1849), and Leroy Washington Cook (June 8, 1852). There was another child, a daughter named Clara, who was born on February 14, 1862. When her birth mother died on March 4, she was adopted by a well-to-do farmer and his family. Her adopted name was Clara Gavett. (Both, courtesy of NARA.)

Born on July 15, 1832, Sylvanus Swain Cook was self-educated and, through reading, study, and attendance at medical lectures, received his diploma from the Cincinnati Medical College in 1858. Cook married Sarah A. Eastburn, and they had five children. He served as assistant surgeon of the 24th Iowa Infantry before being sent to Vicksburg as a contract surgeon. He died of disease at Paw Paw Island, Louisiana, on January 15, 1864. (Courtesy of the author.)

Pvt. Joseph Cox served in the 2nd Tennessee Cavalry, Company C. According to the 1850 census, his parents were James and Elizabeth Cox. They lived in Claiborne County, Mississippi. Cox's father was a planter. He is one of 39 listed in the *Roll of Honor, Issue 24* as having served with Tennessee troops for the Union army. He died at Vicksburg on April 10, 1865. (Courtesy of NARA.)

Horace Crawford served with the 1st Michigan Light Artillery, 8th Battery, also known as the 1st Michigan Light Artillery Regiment, Battery H, during the Vicksburg siege. By the time of his passing, he had attained the rank of corporal. Crawford died on August 25, 1863, in Vicksburg, Mississippi. He is buried alongside Isaac Crawford, who is thought to be his brother. (Courtesy of the author.)

Isaac Crawford married Elsie Carney in 1841. She died on January 21, 1855, at 31 years of age. Pvt. Crawford served with the 1st Michigan Light Artillery, 8th Battery. He died on August 24, 1863, of congestive chills. He was 43. His minor son, Wallace, through his guardian, applied for his pension in 1863. Isaac is buried alongside Horace Crawford, who is thought to be his brother. (Courtesy of NARA.)

Born in Rhode Island in 1842, Frederic E. Davis served in the 4th Rhode Island Infantry Regiment, Companies Q and A. Later Davis served as a seaman on a number of gunboats, including the USS *Baron De Kalb*. In a letter written to his parents dated December 18, 1862, he described the sinking of USS *Cairo*. Mortally wounded at Fort Pemberton, Mississippi, on March 15, 1863, Davis died two days later on March 17 at only 20–21 years old. Davis posed for this photograph in civilian attire. Below are personal belongings of Davis recovered after his death, including a small round tin of toothache powder and a sewing kit (housewife) containing thread, buttons, and buckles. (Both, courtesy of Frederic E. Davis papers, Stuart A. Rose Manuscript, Archives, and Rare Book Library, Emory University.)

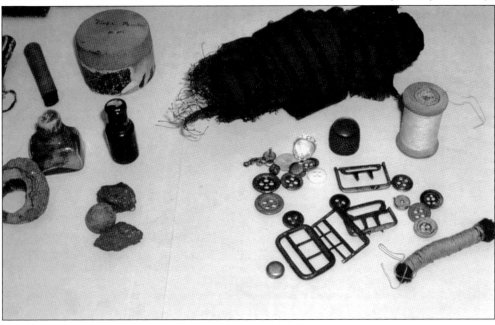

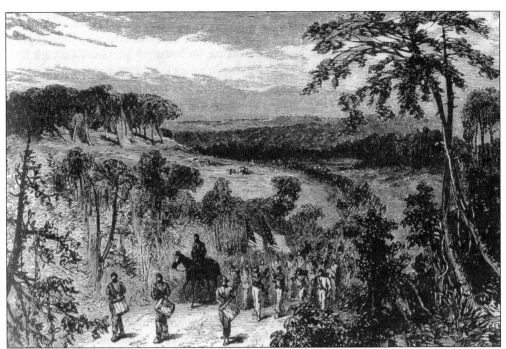

About 24,000 Union troops were ferried across the Mississippi River from Louisiana onto Mississippi soil, landing at Bruinsburg between April 30 and May 1, 1863. One of the first units to cross over was the 33rd Illinois Infantry with Vicksburg as their destination. This sketch from *Harper's Pictorial History of the Civil War* depicts Union troops making landfall. (Courtesy of the author.)

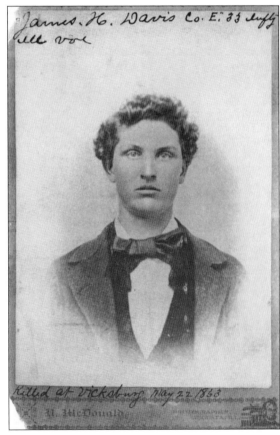

James H. Davis was born on April 9, 1842, in Warren County, Illinois. During the Civil War, he served with the 33rd Illinois Infantry, Company E, referred to as the "Normal" or "Teacher's Regiment." Reaching Vicksburg on May 19, Davis was one of 13 killed during the second assault on Vicksburg, conducted on May 22, 1863, at just 21 years of age. (Courtesy of the author.)

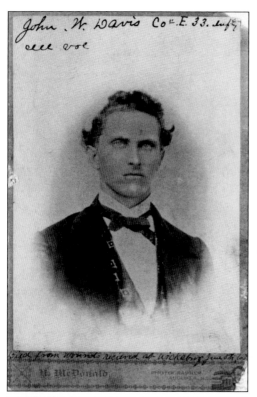

John W. Davis, born on November 17, 1840, is not on the burial list for Vicksburg National Cemetery. However, according to an inscription on his image, he died of wounds sustained at Vicksburg on June 5, 1863. It is thought that he is among the unknown burials. James and John Davis, believed to be brothers, died just weeks apart. (Courtesy of the author.)

Philip Davis was enrolled as a corporal at Milliken's Bend, Louisiana, on May 1, 1863, and mustered into service on August 7, 1863, at Vicksburg to serve three years in the 5th US Colored Heavy Artillery, Company D. He was born in Woodford County, Kentucky, and was 28 years old. (Courtesy of the author.)

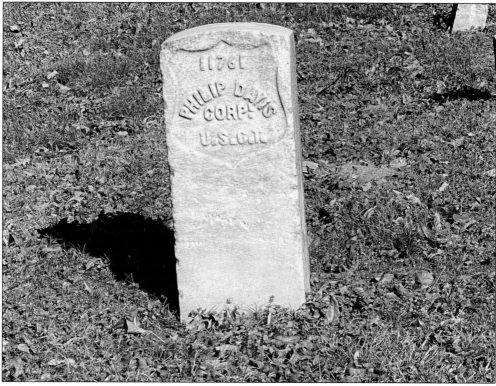

This discharge document states that Philip Davis stood 5 feet and 1.75 inches tall with a black complexion, black eyes, and curly hair. He had been paid $47 and issued a haversack. Other personal effects found with Davis included his clothing and a woolen blanket. Before the war, he had been a farmer. He died in the regimental hospital at Vicksburg on February 28, 1865, of general debility. (Courtesy of NARA.)

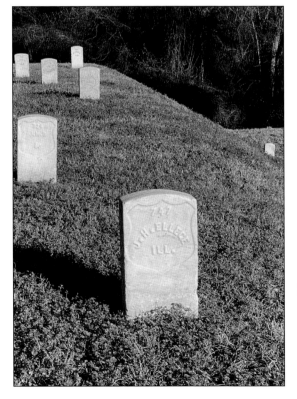

Originally from Pike County, Illinois, Joel H. Elledge served as a musician with the 99th Illinois, Company B. He died on April 11, 1863, at between 21 and 22 years of age and was originally buried at Milliken's Bend. At his death, he was survived by both parents, a brother, and three sisters. (Courtesy of the author.)

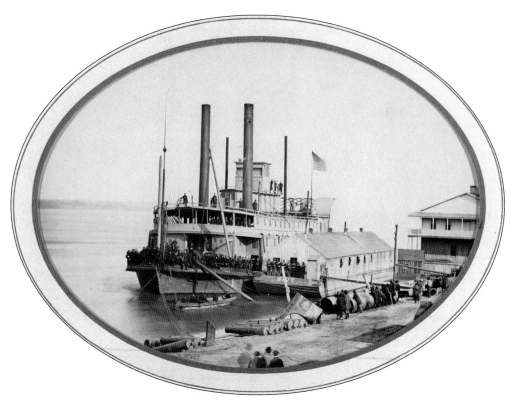

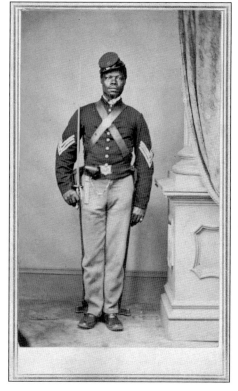

Acting ensign Richard Ellis served as commander of the USS *Great Western*, which was constructed in Cincinnati, Ohio, in 1857. *Great Western* was used as an ordnance supply vessel, providing ordnance to vessels in support of the efforts to take Vicksburg, and remained until Vicksburg surrendered on July 4, 1863. Ellis died on September 5, 1863. (Courtesy of LOC.)

Born in 1832 in Kentucky as an enslaved person, Sgt. Charles English joined the military without the permission of his enslaver. With the 108th US Colored Troops Infantry Regiment, Company C, he served at Vicksburg, where he died of disease on August 27, 1865. He is believed to be among the unknown burials. During America's Civil War, 200,000 African Americans enlisted in the Army or Navy. (Courtesy of LOC.)

Cpl. Edward C. Eyman and his two brothers, Lewis and John, enlisted in the Union army at Harristown, Macon County, Illinois. He served with the 116th Illinois Infantry, Company E. Edward Eyman died and was originally buried at Milliken's Bend on April 26, 1863. His name can be found among the 36,000 troop names featured on the bronze panels lining the inner perimeter of the Illinois Memorial (below) located within Vicksburg National Military Park. John was the only survivor of the three but did not live long following the war due to health issues contracted during the war. Edward is the only one of the three brothers to be buried in Vicksburg National Cemetery. He was 23 years old. (Right, courtesy of the author; below, courtesy of LOC.)

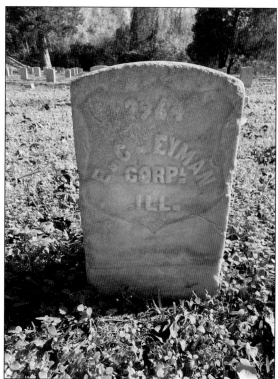

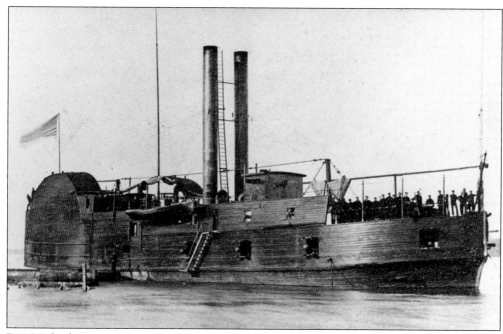

Pvt. Michael Figi served in the 72nd Illinois Infantry, Company F, during the Civil War. His regiment was organized in Cook County, Illinois, and prior to the war, he lived in Chicago. He was mustered into service on August 21, 1862. He served on board the USS *Conestoga* and was killed near Vicksburg, Mississippi, on May 19, 1863, during the first assault on Vicksburg. (Courtesy of NHHC.)

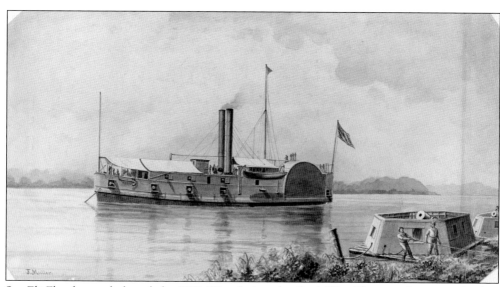

Sn. Eli Flood served aboard the USS *Tyler* during the Civil War. This vessel was involved in operations on the Yazoo River and was one of the first to exchange cannon fire with the CSS *Arkansas* on July 15, 1862. On January 19, 1865, Flood was killed in an ordnance accident while serving aboard *Tyler*. He was only 21 years old. (Courtesy of NHHC.)

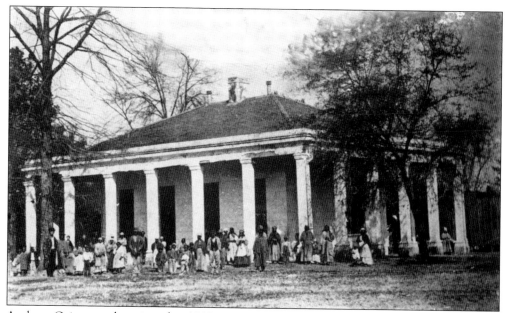

Anthony Gaiters was born in either 1848 or 1850 on Hurricane Plantation (home of Joseph Emory Davis, older brother of Jefferson Davis) in Warren County, Mississippi. Hurricane Plantation was located on Davis Bend, now Davis Island. Before the Civil War, Gaiters was a laborer for Davis, who owned 365 slaves. (Courtesy of the photographic collection of Old Court House Museum.)

At approximately 16 years of age, Anthony Gaiters was mustered into the US Navy in April 1864. He served aboard the USS *Mound City*, the sister ship of USS *Cairo*, as a first-class boy. Gaiters married Lizzie "Littie" Mason. After the war, he worked as a farmhand, and his wife kept house. He died on October 29, 1923. (Courtesy of the author.)

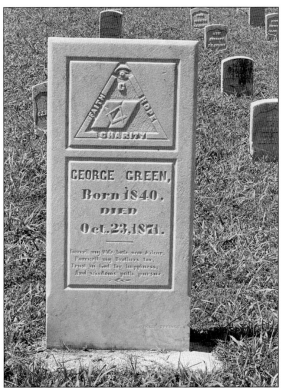

Born in 1840, Sgt. George Green served in the US Infantry during the Civil War. The words "Faith," "Hope," and "Charity" are written in a triangle surrounding what appears to be a Masonic emblem. Green died on October 23, 1871, at 31 years of age. His epitaph reads, "Farewell my Wife both near & dear. Farewell my Brothers too. Trust in God for happiness. And wisdoms path pursue." (Courtesy of the author.)

Pvt. Henry William Hart and Almeda Sumner Butler Hart had only been married a short while when the Civil War began. He enlisted in the 127th Illinois Infantry, Company F, and she followed. When Sherman ordered that women would no longer be allowed, she disguised herself as a soldier serving as a courier for Brig. Gen. David Stuart. The adventure ended when he died on March 2, 1863. (Courtesy of the author.)

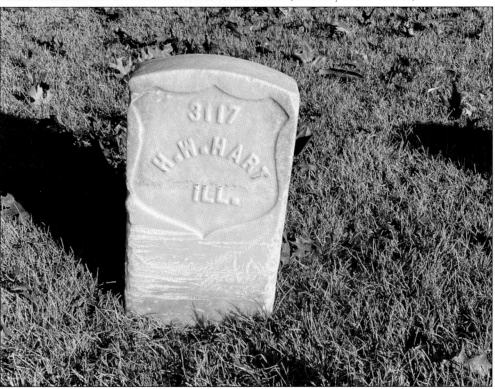

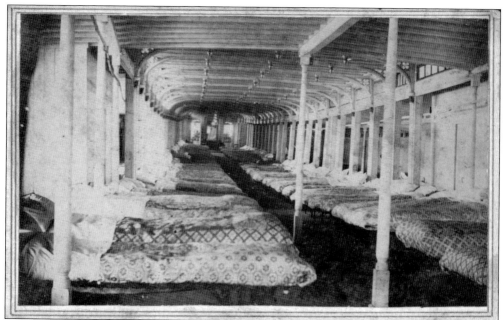

Cpl. Eli Hostetler served with the 96th Ohio, Company H, during the Civil War. He died on the steamer *City of Louisiana* on January 17, 1863. This vessel was outfitted by the Sanitary Commission and was essentially a floating hospital. She was later renamed the *R.C. Wood*. Hostetler was originally buried in Napoleon, Arkansas, before being reinterred in the Vicksburg National Cemetery. (Courtesy of LOC.)

Surgical Steward James Cassius Howe was born in Athens, Ohio, on September 5, 1845, to Dr. James Fuller Howe and Hannah Bingham Howe. He enlisted in the US Navy for a two-year term in Cincinnati on February 1, 1865. He served aboard the USS *Oriole* but died on April 15, 1865, while at Natchez, Mississippi. He was 19 years old. (Courtesy of NHHC.)

Sn. John Jackson first served in the Civil War in the Union navy, having first enlisted in 1864 as a first-class boy on board the USS *Paul Jones*. He was discharged from his first enlistment in 1867. In 1869, Jackson reenlisted, serving as a landsman performing tasks such as a coal heaver in the US Navy. He later filed for disability/pension (below), claiming he suffered from melancholia (perhaps suffering from what is known today as post-traumatic stress disorder). The document at left outlines Jackson's enlistments, listing his rank and duration of service as well as vessels on which he served. Jackson died on June 26, 1917. (Both, courtesy of NARA.)

Capt. Henry M. Kellogg served in the 33rd Illinois Infantry, Company C, during the Civil War. He was killed at Vicksburg on May 20, 1863. The 33rd was one of the first regiments to be ferried across the Mississippi River from Louisiana between April 30 and May 1. Since there is no headstone for Kellogg within the cemetery, he is presumed among the unknown burials. (Courtesy of LOC.)

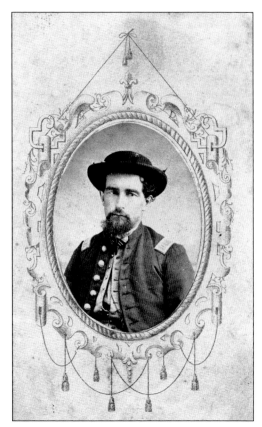

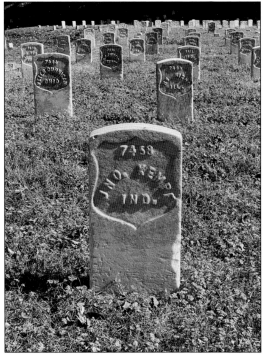

John Kempf was born in Switzerland and immigrated to the United States. He fought in the Civil War and served with the 48th Indiana, Company H. Kempf married Christina Kaufmann Bickel, who had emigrated from Switzerland in 1853. The two were married in 1861. He died at Vicksburg on September 15, 1863. (Courtesy of the author.)

Pvt. Edward Lewis mustered into service on January 23, 1864, serving in the 2nd Wisconsin Cavalry, Company I. At enlistment, he was living in Dodgeville, Wisconsin. On September 5, 1864, he died of disease while in Vicksburg. The Wisconsin Memorial stands as a lasting tribute to all Wisconsin soldiers who fought in the Vicksburg campaign. The left side of the memorial features a cavalryman. (Courtesy of LOC.)

Born in Connecticut in approximately 1834, George Lounsberry was living in Rye, Westchester County, New York, in 1860 before enlisting in the military. While serving as master's mate on Rear Adm. David Farragut's flagship, USS *Hartford*, Lounsberry was killed by a cannonball during the engagement with CSS *Arkansas* on July 15, 1862. He was 27 and one of three killed that day on board *Hartford*. (Courtesy of NHHC.)

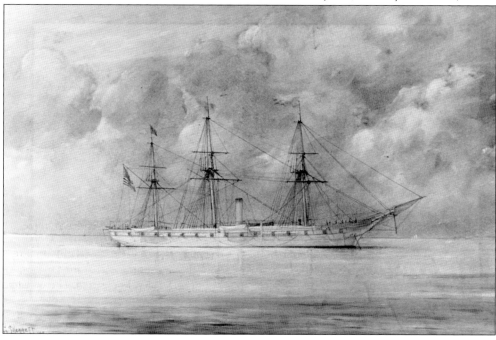

In a letter published in the *Nashville Dispatch*, Lt. Frederick Haywood wrote regarding Sgt. Alfred J. Luther: "She was brave as a lion in battle and never flinched from the severest fatigues or the hardship duties. . . . She was a sergeant when she died." Luther enlisted in the 1st Kansas Infantry, Company A, as a woman disguised. Contracting smallpox at Lake Providence, Louisiana, she died on March 22, 1863. (Courtesy of the author.)

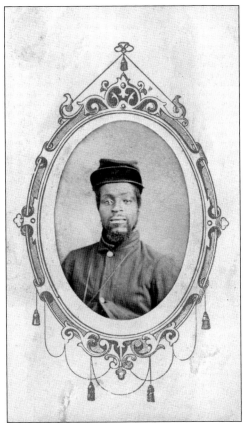

Born in Kentucky, Kager Mays served in the 108th US Colored Troops, Company C. In May 1865, the 108th left Rock Island, Illinois, on board the transport vessel *Maria Denning*, arriving in Vicksburg, Mississippi, 11 days later. Mays died of disease on August 12, 1865, at Vicksburg, and it is thought that he is among the unknown burials. (Courtesy of LOC.)

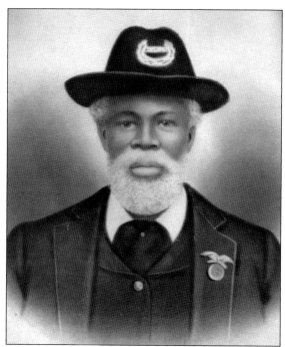

Pvt. Andrew Mitchell served with the 50th US Colored Infantry, Company B. Both he and his wife, Elizabeth, lived in Vicksburg. He died on December 3, 1903. She passed on July 29, 1927. This photograph, in which Mitchell is wearing his GAR medals, was donated to the Old Court House Museum by Frances Thompson, Mitchell's great-great-granddaughter. (Courtesy of the photographic collection of Old Court House Museum.)

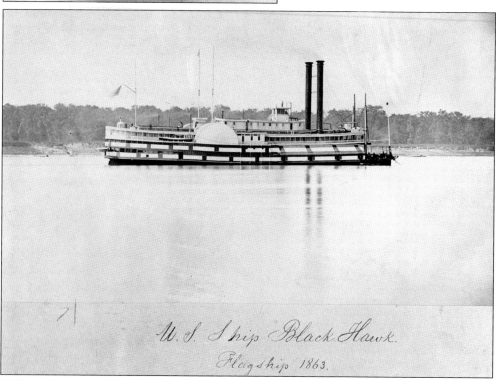

William Neely served as a fireman aboard the USS *Black Hawk*, a large tinclad built in 1848 in New Albany, Indiana. The vessel carried a complement of 141 and served as the flagship of the Mississippi Squadron during operations at Vicksburg. Neely died on July 27, 1863, at De Soto Parish, Louisiana. (Courtesy of NARA.)

Born August 27, 1845, Sgt. William W. Nesmith served in the 15th US Infantry, 2nd Battalion, Company A, during the Civil War. He enlisted on April 8, 1865, and was discharged on April 8, 1868. He married Elmira Nee McLeod in 1893. The couple lived in Vicksburg. Elmira passed on October 24, 1920. William died on May 30, 1923, at 77. He is buried with Elmira in the cemetery. (Courtesy of the author.)

Pvt. Benjamin Franklin Nussbaum was born in 1844 to Isaac and Julia Ann (Mellinger) Nussbaum. He enlisted on August 1, 1862, at the age of 18 and was mustered into the 23rd Iowa Infantry Regiment, Company B, on August 21, 1862. Nussbaum was wounded on June 14, 1863, at Vicksburg, dying on June 20, 1863, at Carr's Hospital in Vicksburg between 18 and 19 years of age. (Courtesy of the author.)

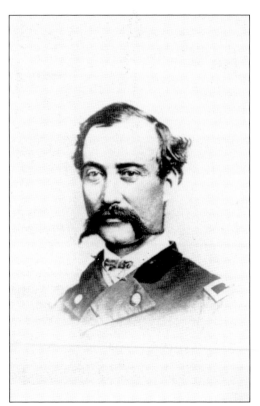

Born on June 6, 1832, in New York, Embury Durfee Osband enlisted in the Union army on August 23, 1861, mustering in on September 26, 1861. In the western theater of the war, he served as General Grant's unit escort and was brevetted brigadier general of US Volunteers in 1864. He resigned in 1865 to take up cotton farming in Yazoo County, Mississippi. (Courtesy of Massachusetts MOLLUS Collection.)

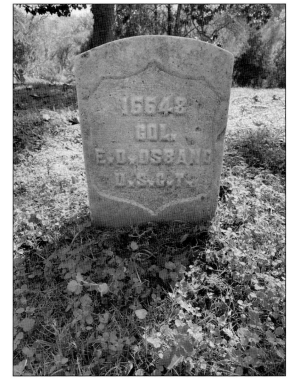

Embury D. Osband died of encephalitis on October 4, 1866, in Yazoo County, Mississippi, at 34. In January 1893, friends requested his interment in Vicksburg National Cemetery, since his original gravesite at Caroline Landing in Washington County, Mississippi, was in danger of being washed away by the river. Permission was granted, and his remains were interred 27 years after his death. He is the highest-ranking veteran in the cemetery. (Courtesy of the author.)

Pvt. William L.H. Pumplin was born on July 11, 1829, in Germany and immigrated to the United States in 1854 with his wife, Elizabeth, and their son Heinrich. They had three other children. William was naturalized in 1860 and soon after enlisted in the Army, serving in the 12th Wisconsin Infantry, Company A. He died of disease on July 6, 1863, at Magnolia Hall in Vicksburg. He was 33 or 34. (Courtesy of the author.)

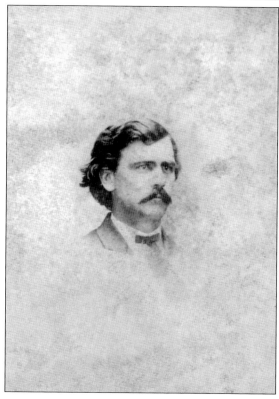

Born in 1841, William Titus Rigby served in the Civil War as a second lieutenant in the 24th Iowa Infantry, Company B, and was promoted to captain. He fought at Vicksburg. In 1869, he graduated from Cornell College in Mount Vernon, Iowa, where he met and later married Eva Cattron. (Courtesy of William Titus Rigby and William Cattron Rigby Papers [msc0082], the University of Iowa Libraries.)

Elected secretary of the Vicksburg National Military Park Association in 1895, Captain Rigby worked closely with veterans and was very instrumental in the establishment of Vicksburg National Military Park, marking troop locations and working toward the placement of state memorials. He became the park's resident commissioner in 1899, dying on May 10, 1929. He is buried beside Eva Rigby at Vicksburg National Cemetery. (Courtesy of VNMP.)

Eva Cattron Rigby met her future husband, William Titus Rigby, at Cornell College in Iowa. They married in 1869 and had three children. Her photograph was taken at the Vicksburg Studio in Vicksburg, Mississippi. She died on December 26, 1928, and is buried beside William Rigby. (Courtesy of William Titus Rigby and William Cattron Rigby Papers [msc0082], the University of Iowa Libraries.)

Lizzie Robb served as a Civil War nurse with the 72nd Illinois. At the beginning of the Civil War, Robb and her sister, Annie Robb, both enlisted. Lizzie Robb died at Paw Paw Island, Mississippi, when she was shot through the breast and killed on December 31, 1863, while administering to the needs of the 72nd Illinois. The marker at right was erected by the Women's Relief Corps (WRC) at a cost of $200. Her sister survived the war. They were both of Scottish descent. Annie Robb was later admitted to the Scottish Home for the Elderly with funds secured through the WRC. Lizzie Robb was originally buried at Paw Paw Island before being reinterred in Vicksburg National Cemetery. The below image is of the Women's Relief Corps. (Right, courtesy of the author; below, courtesy of LOC.)

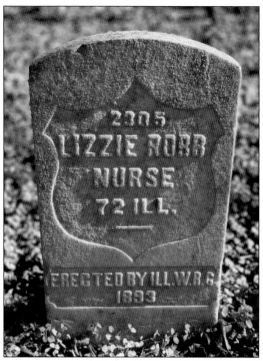

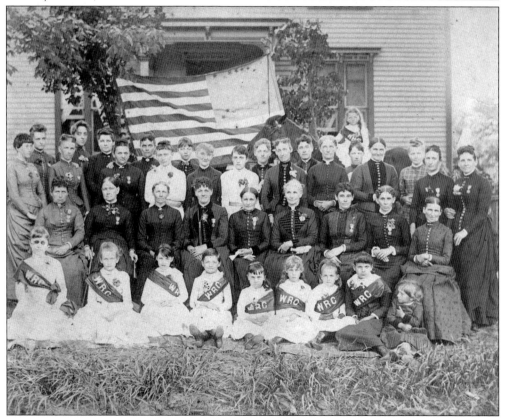

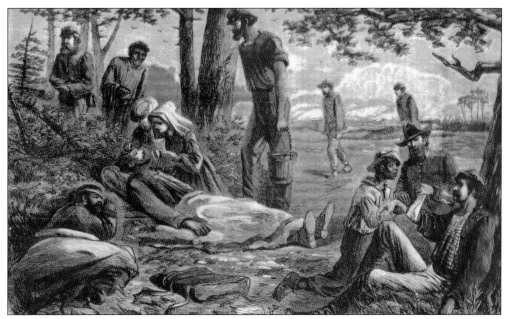

This sketch from *Harper's Pictorial History of the Civil War* depicts a Civil War nurse, such as Lizzie Robb or Mary Ann Bickerdyke, who although not buried at Vicksburg also attended to the needs of the sick and wounded on the Vicksburg battlefield, providing medical supplies and a measure of comfort to those in need. Lizzie Robb was killed on December 31, 1863, at Paw Paw Island. (Courtesy of the author.)

Born in 1834 to parents Jacob and Esther Roby, Pvt. Abraham Roby was from Boone County, Indiana. He served with the 11th Iowa, Company G, during the Civil War. He died on June 2, 1863, from wounds sustained at Champion Hill on May 16, 1863. He was 28–29 years of age at death. (Courtesy of the author.)

Pvt. Joseph Rosenberger served in the 60th Indiana Volunteer Infantry, Company A, during the Civil War. He died on July 11, 1863, from dysentery. He was originally buried at a graveyard at Marshall's plantation, Madison Parish, Louisiana. He is buried in Vicksburg National Cemetery in Section H, Grave No. 1. The 60th Regiment lost 165 enlisted from disease. (Courtesy of the author.)

Born in 1837, Pvt. James Sellers enlisted in the Union army on August 13, 1862, serving with the 23rd Indiana Infantry, Company E. Sellers died of disease on June 30, 1863, in Vicksburg, Mississippi. On a note recovered with his remains, the following was written, "Tis sweet to die for one's Country." This notation is found on original cemetery field sheets, which list his death date as June 23, 1863. (Courtesy of the author.)

Pvt. Edward H. Shell served in the 2nd Arkansas Volunteer Infantry, Company A, in the Union army during the Civil War. Although Arkansas had seceded from the United States in 1861, not all of its citizens supported this decision, and as a result, 11 regiments from Arkansas served in the Union army. Shell died on February 4, 1863. (Courtesy of the author.)

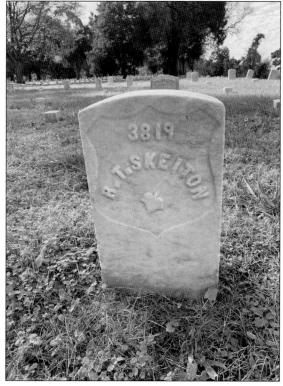

One of at least four known Confederates accidentally buried within Vicksburg National Cemetery, Robert T. Skelton enlisted in Enterprise, Mississippi, on March 7, 1862. He served with the 37th Mississippi Volunteers, Company D, and Pound's Battalion. He died in the vicinity of Jackson, Mississippi. Etched on his headstone is the symbol of an acorn, which symbolizes strength, power, independence, triumph, and perseverance. (Courtesy of the author.)

Dr. James Bog Slade, a Mexican-American War veteran, was born on April 5, 1803, in Martin County, North Carolina. He served as a surgeon for the 15th North Carolina Infantry during the Mexican-American War. Dr. Slade died on November 30, 1847, at 43 years of age in Mexico City, Cuauhtémoc Borough, Distrito Federal, Mexico. Slade was originally buried in New Orleans, Louisiana, in the Girod Street Cemetery. (Courtesy of the author).

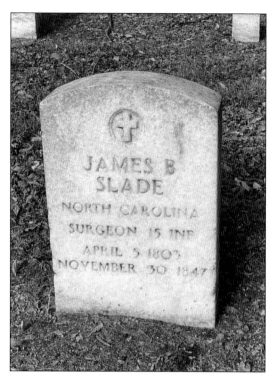

The Girod Street Cemetery, New Orleans's oldest Protestant cemetery, below, fell into disrepair. In 1957, it was demolished once all of the burials were relocated. Slade's remains were reinterred in Vicksburg National Cemetery on January 19, 1949. Slade had a daughter named Amelia Slade, who was born February 1, 1830, but only lived to be 15, dying on April 5, 1845. (Courtesy of City Archives & Special Collections, New Orleans Public Library.)

"It is in a beautiful place just under the shade of a noble tree" describes the burial plot of Pvt. Harlan A. Squire in the book *Wisconsin at Vicksburg*. Squire was born in 1844 to Stephen and Maria Squire and had one sister. During the war, he served in the 12th Wisconsin Infantry, Company E. He was 19 years old when he died on June 28, 1863. (Courtesy of the author.)

Pvt. Marble F. Stone, whose headstone is marked as Marble Flintstone, served with the 96th Ohio, Company I, which mustered into service on August 29, 1862, at Camp Delaware, Ohio. He died of an unspecified disease on May 18, 1863, at only 20 years of age at Milliken's Bend, Louisiana. Stone was initially buried in Madison Parish, Louisiana, before being reinterred in Vicksburg National Cemetery. (Courtesy of the author.)

Lt. Xavier St. Pierre served in the 76th Illinois, Company D, which was mustered into service at Peoria, Illinois, on September 3, 1862. The 76th participated in the campaign for Vicksburg and all siege operations and was engaged in actions at Port Gibson, Champion Hill, Big Black River Bridge, and the assault on Railroad Redoubt, where it planted its colors in the fort. St. Pierre died on October 4, 1864. (Courtesy of the author.)

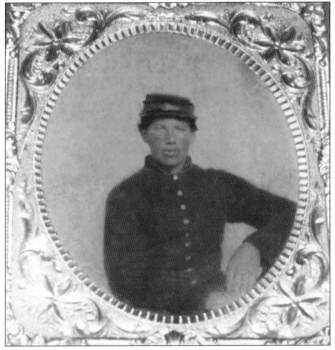

Pvt. John Summers, born in 1844 to Peter and Hannah Sheffield Summers, had two sisters and two brothers. During the Civil War, Summers served with the 14th Wisconsin Infantry Regiment, Company A. On May 22, 1863, the 14th lost 107 men, including Summers, who was 18–19 years old. When disinterred for burial in the national cemetery, he was found with a likeness of a young lady. (Courtesy of Peter Summers.)

Topping the private marker (pictured left) of Edward Tollinger is the epitaph "His memory is revered by his many friends." Tollinger was born in Lancaster County, Pennsylvania, on September 20, 1844. He enlisted in Lancaster on July 14, 1864, and was mustered into service of the Union army at Harrisburg, Pennsylvania, on July 17 as a private in the 195th Pennsylvania Volunteer Infantry, Company C. He was honorably discharged on November 4, 1864. Tollinger married Matilda Esther "Tillie" Hanna in 1878. The couple resided in Lancaster County and were married for 28 years before her passing in 1906. By 1910, Tollinger was living and working in Vicksburg as a civil engineer. He died in Vicksburg on June 18, 1924. One of the more prominent memorials in Vicksburg National Military Park is the Pennsylvania Monument, dedicated in 1906. (Left, courtesy of the author; below, courtesy of LOC.)

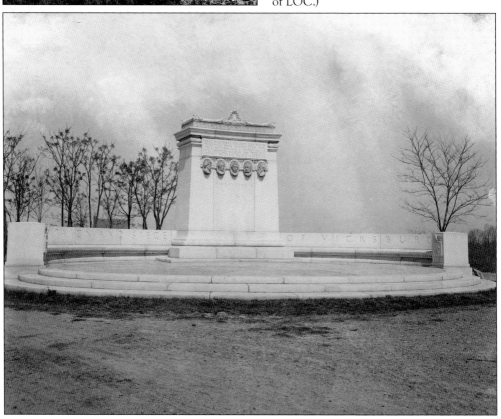

Pvt. Asbury Turner was only 18 years old when he was killed by an artillery round on July 10, 1863, in the vicinity of Jackson, Mississippi, where he was originally buried. Turner enlisted on August 4, 1862, and served with the 96th Ohio Infantry, Company K. He was engaged in the following battles with his company before his death: Chickasaw Bayou, Arkansas Post, Vicksburg, and Jackson, Mississippi. (Courtesy of the author.)

Pvt. King Vance joined the Union army at Holly Springs, Mississippi, in December 1863. Vance served in the 64th US Colored Infantry, Company H. The prewar occupation for the five-foot-five-tall Vance was as a farmer. He died on October 14, 1865, in Hospital No. 3 in Vicksburg, Mississippi. The cause of death was listed as acute dysentery. (Courtesy of the author.)

F.W., whose full name is unknown, was documented as having fought in the Civil War serving with the 131st Illinois, Company C. Records indicate that F.W. died and was buried at Young's Point, Louisiana (since this brigade served on the west side of the river), before being reinterred within Vicksburg National Cemetery. His date of death is unknown. (Courtesy of the author.)

Patrick Walsh was born in 1845 in England. He immigrated to the United States and enlisted in the Union army in Keokuk, Iowa, at 16. His enlistment records describe him as being 4-foot-11, blue-eyed, fair-complexioned, with brown hair. Walsh served as a musician for the 13th Infantry Regiment, 1st Battalion, Companies B and F. He suffered a gunshot wound on May 19 and died on June 8, 1863, at 17–18 years. (Courtesy of the author.)

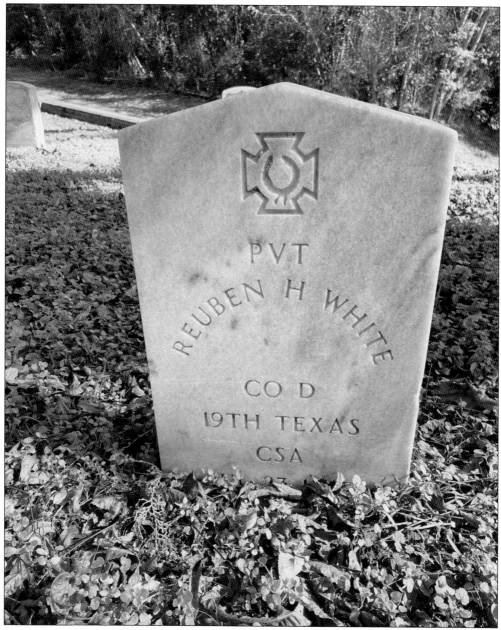

One of four known Confederates accidentally buried within Vicksburg National Cemetery, Pvt. Reuben Henry White served in the Trans-Mississippi Department, 19th Texas Infantry Regiment, Company D. He was born in 1828 in Georgia and was married to Mary Brazel. The couple had four children, a daughter and three sons, one of whom was also named Reuben (spelled Ruben) Henry White, born on July 10, 1863. White died on July 23, 1863, and was originally buried at Marshall's plantation, Madison Parish, Louisiana, before being reinterred in Vicksburg National Cemetery. He had a brother named James William White who also fought at Vicksburg for the Confederacy. Pvt. James White served with the 56th Georgia Infantry, Company I. He was killed at Vicksburg on May 3, 1863. The location of his grave is unknown. He was married to Sallie Minerva Hildebrand White, and the two had a daughter born in 1862. (Courtesy of the author.)

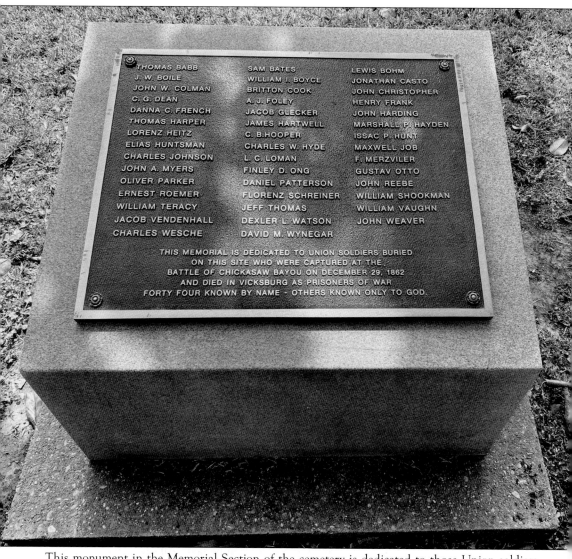

THOMAS BABB	SAM BATES	LEWIS BOHM
J. W. BOILE	WILLIAM I. BOYCE	JONATHAN CASTO
JOHN W. COLMAN	BRITTON COOK	JOHN CHRISTOPHER
C. G. DEAN	A. J. FOLEY	HENRY FRANK
DANNA C. FRENCH	JACOB GLECKER	JOHN HARDING
THOMAS HARPER	JAMES HARTWELL	MARSHALL P. HAYDEN
LORENZ HEITZ	C. B. HOOPER	ISSAC P. HUNT
ELIAS HUNTSMAN	CHARLES W. HYDE	MAXWELL JOB
CHARLES JOHNSON	L. C. LOMAN	F. MERZVILER
JOHN A. MYERS	FINLEY D. ONG	GUSTAV OTTO
OLIVER PARKER	DANIEL PATTERSON	JOHN REEBE
ERNEST ROEMER	FLORENZ SCHREINER	WILLIAM SHOOKMAN
WILLIAM TERACY	JEFF THOMAS	WILLIAM VAUGHN
JACOB VENDENHALL	DEXLER L. WATSON	JOHN WEAVER
CHARLES WESCHE	DAVID M. WYNEGAR	

THIS MEMORIAL IS DEDICATED TO UNION SOLDIERS BURIED
ON THIS SITE WHO WERE CAPTURED AT THE
BATTLE OF CHICKASAW BAYOU ON DECEMBER 29, 1862
AND DIED IN VICKSBURG AS PRISONERS OF WAR
FORTY FOUR KNOWN BY NAME - OTHERS KNOWN ONLY TO GOD.

This monument in the Memorial Section of the cemetery is dedicated to those Union soldiers who were captured at the Battle of Chickasaw Bayou and later died as prisoners in Vicksburg. The plaque bears the following inscription: "This memorial is dedicated to Union soldiers buried / on this site who were captured at the / Battle of Chickasaw Bayou on December 29, 1862 / and died in Vicksburg as prisoners of war / forty-four known by name—others known only to God." In a letter written by Capt. Lewis Eyman, who served with his brother Edward (who is buried in the cemetery) in the 116th Illinois Infantry, Company E, Eyman gives a firsthand account of his experience at the Battle of Chickasaw Bayou: "We was in awful thick timber in an awful swamp, the bullets came among us as thick as hail. Every tree perforated with bullets." (Courtesy of the author.)

Three

DUTY, HONOR, COUNTRY
SPANISH-AMERICAN WAR
THROUGH KOREAN WAR

Howard William Osterkamp, a Korean War veteran and Purple Heart recipient, summed up the many sacrifices made by our courageous military forces when he said, "All gave some, some gave all." Vicksburg National Cemetery provides a final resting place for the brave veterans of the Spanish-American War, Philippine-American War, World War I, World War II, and the Korean War, for without their service, this would not be home of the free. The following pages reveal the stories of those interred within this hallowed ground and their extraordinary actions to ensure the safety and security of this great nation.

William Martin Anderson was born on January 24, 1920, in Amarillo, Texas. He graduated from Perkinston Junior College (now Gulf Coast Community College) in 1941. This photograph is featured in that year's school annual, entitled *Perkolator*. He took part in the school's Dramatic Club, Baptist Young People's Union, Glee Club, and Young Men's Christian Association and was inducted into Phi Beta Kappa. (Courtesy of GCCC Archives.)

1st Lt. William M. Anderson piloted a B-17, like this one, nicknamed "Panhandle Dogie" in the Army Air Corps, 91st Bombardment Group, 323nd Squadron, in World War II. The first "Panhandle Dogie" was severely damaged during a bombing mission. Anderson and his crew made it back. The plane was displayed at an English airfield as an example of what was expected of their pilots. (Courtesy of NARA.)

On January 3, 1943, Anderson was flying the second "Panhandle Dogie" when he was shot down. He was declared missing from 1943 until his grave was located and his remains were identified in 1950. He was promoted to captain after he was declared missing. He was 22 when he died on January 3, 1943. This image, although not of Anderson, is of the 91st Bombardment Group, 323nd Squadron. (Courtesy of NARA.)

Throat mikes and earphones were used by pilots to communicate with their crew. 1st Lt. William M. Anderson, pilot of the Boeing B-17 "Panhandle Dogie," served in the 91st Bombardment Group, 323nd Squadron, nicknamed the "Ragged Irregulars." His plane was shot down on January 3, 1943. Services were held for 1st Lt. William Martin Anderson on September 30, 1950, in Vicksburg National Cemetery. (Courtesy of NARA.)

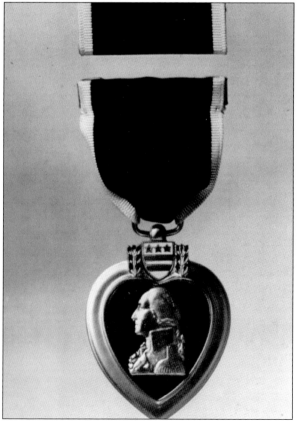

Cpl. William Benjamin Barnett, born on December 18, 1923, was from Neshoba County, Mississippi. During World War II, he served in the US Marine Corps in the 5th Marine Division. On February 24, 1945, he was killed at 21 while engaged in combat on Iwo Jima. The US Marine Corps War Memorial depicts Marines planting an American flag on Mount Suribachi. (Courtesy of LOC.)

Barnett was posthumously awarded the Purple Heart. Following the battle, Adm. Chester A. Nimitz of the US Navy stated that "by their victory, the 3rd, 4th and 5th Marine Divisions and other units of the 5th Amphibious Corps have made an accounting to their country which only history will be able to value fully. Among the Americans serving on Iwo Island, uncommon valor was a common virtue." (Courtesy of NHHC.)

San Francisco 1900. En route to Philippines

Born on September 4, 1874, Charles Horace Bartley Jr. was 24 when he fought in the Spanish-American War. On July 11, 1901, while in the Philippines during the Philippine-American War, Private Bartley re-enlisted for a term of three years. He served in the 9th US Cavalry, Troop E, one of the "Buffalo Soldier" regiments. While awaiting deployment to the Philippines in 1900, these regiments camped on the San Francisco Presidio and guarded the Sequoia, General Grant, and Yosemite National Parks before the establishment of the National Park Service, thus becoming the first African American park rangers. When Bartley completed his draft registration for World War I on September 12, 1918, he was 44 and had been working as a laborer for Finkbine Lumber Company in Wiggins, Mississippi. In September 1922, he drew an invalid pension. Bartley died on November 8, 1950, at 76. (Courtesy of Fort Huachuca Museum.)

Pfc. Robert E. Lee Beyers was born in Fannin, Texas, on March 15, 1893, to Lydia Mhoon and John Beyers. During World War I, he served in France. Following his service, he, his wife, Reber, and their two sons, Robert and Leo, made their home in Vicksburg, where he worked as a watchman for Standard Oil Company. He died on November 21, 1945, at 52. (Courtesy of Bobbie Beyers Edwards.)

When Robert E. Lee Beyers enlisted for service in World War I, he was married and living in Ferda, Arkansas. He was inducted into the military at Camp Pike, Arkansas. He served from 1917 to 1920 in the US Army Motor Cycle Company within the Quartermaster Corps and was deployed to France. He was honorably discharged on September 8, 1920. (Courtesy of LOC.)

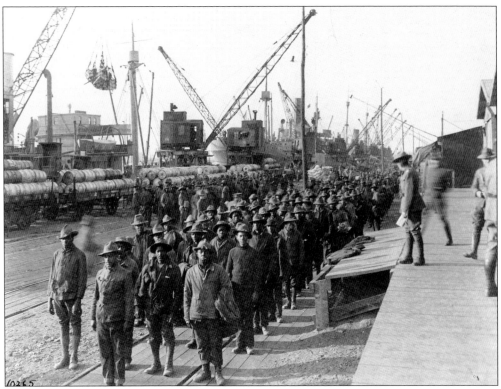

Pvt. Edward Bryant was born in 1882 in Vicksburg, Mississippi. On January 24, 1903, Bryant married Esther Florence Fife, and they had three sons. During World War I, he served in the 302nd Stevedore Regiment (Quartermaster Corps), Company D. Pictured here, a stevedore regiment lines up at an American port facility in France, where they aided American Expeditionary Forces through the unloading of supplies. (Courtesy of NARA.)

Pvt. Edward Bryant died of tuberculosis while in Bordeaux, France, on June 6, 1919. His remains were transported to Ellis Island on the troop transport vessel USS *Wilhemina* and subsequently on to Vicksburg National Cemetery, where he was laid to rest. Pvt. Edward Bryant's name is featured on the war memorial located in the Rose Garden in downtown Vicksburg. (Courtesy of NHHC.)

Robert Whitefield Bullen II was born in Fayette, Mississippi, in 1887. During World War I, Private First Class Bullen served with the 4th Mississippi Infantry, Company A, following his training at Camp Shelby in Hattiesburg, Mississippi. Infantrymen in World War I were nicknamed "Doughboys." He was deployed to Brest, France, from October 2, 1918, to August 23, 1919. (Courtesy of Andrew Bullen.)

Bullen was shipped back to the States aboard the USS *Huron* and honorably discharged on September 2, 1919. He married Katie Wiehl Foster in 1926 in Warren County, Mississippi. The two had a son, Robert Whitefield Bullen, and a daughter, Mary King Bullen. He passed in 1934 in Fayette, Mississippi. Katie died in 1998 in Birmingham, Alabama, and is buried alongside her husband. (Courtesy of NHHC.)

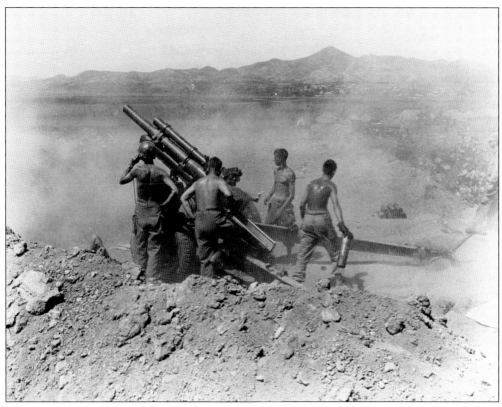

Cpl. Sam Charleston Jr., born in 1924 in Mississippi, enlisted on December 29, 1945, at Fort McClellan, Alabama. He served in both World War II and the Korean War. During the Korean War, Charleston served in the 25th Infantry Division, 24th Infantry Regiment, 1st Battalion, C Company. In this image, a gun crew of the 25th Infantry Division fires on North Korean positions near Uirson, South Korea, on August 27, 1950. (Courtesy of NARA.)

Cpl. Sam Charleston Jr. was killed in action on September 8, 1950, in South Korea. He was posthumously awarded the Purple Heart, the Combat Infantryman's Badge, the Korean Service Medal, the United Nations Service Medal, the National Defense Service Medal, the Korean Presidential Unit Citation, and the Republic of Korea War Service Medal. He was married to Ruby Charleston with one daughter. (Courtesy of the author.)

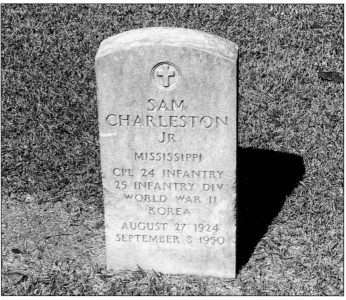

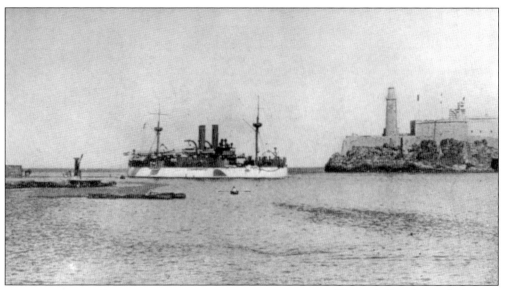

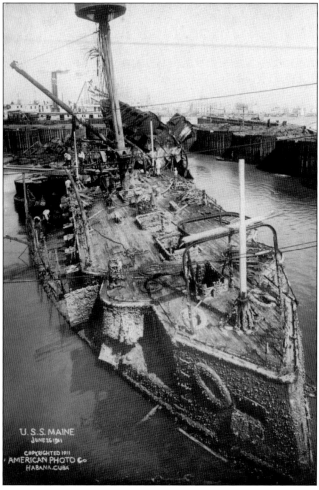

The explosion that sank the USS *Maine* on February 15, 1898, was a catalyst for the Spanish-American War. The tragic incident resulted in the loss of 266 US sailors. The above photograph shows the USS *Maine* passing Morro Castle and entering Havana Harbor, Cuba, on January 25, 1898, three weeks before her sinking. Two months later, Congress passed a joint resolution acknowledging Cuba's independence from Spain and ordering Spain to relinquish all control over Cuba. The resolution further authorized Pres. William McKinley to implement all necessary military actions to safeguard Cuba's independence. In retaliation, the Spanish government rejected these demands, cutting all diplomatic ties with the United States. President McKinley reciprocated by ordering a naval blockade of Cuba and issuing an order for 125,000 military troops, called "volunteers." At left is the USS *Maine* following her raising in 1911. (Both, courtesy of NHHC.)

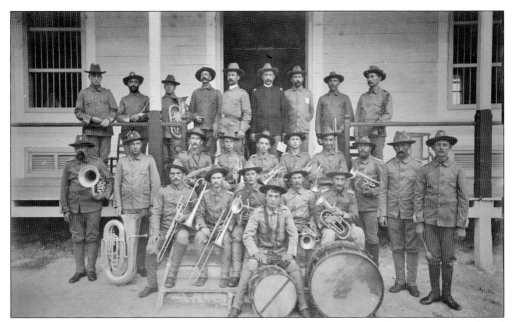

Pvt. William Walker Darracott was born in Augusta, Georgia, on April 17, 1874. He enlisted in the Army in 1898 and served in the Spanish-American War as a musician with the 29th US Volunteer Infantry, Company K. Musicians such as the ones featured played a vital role in improving soldiers' morale through the playing of patriotic songs that served to encourage troops. (Courtesy of NARA.)

Discharged in 1901, William Darracott then worked as a carpenter. He married Mary Ella Crocker, and their daughter, Ila May, was born in 1910, dying 10 years later. In 1928, William was admitted to the National Home for Disabled Volunteer Soldiers, Mountain Branch, which included this chapel. Ella passed in 1935 in South Carolina, where she is buried with their daughter. In 1940, William died. (Courtesy of LOC.)

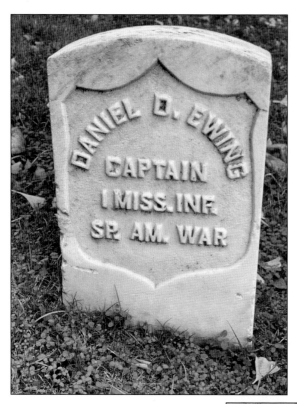

Capt. Daniel Deúnett Ewing was born in New Orleans, Louisiana, on November 1, 1870. During the Spanish-American War, he served in the 1st Mississippi Infantry, Company H, called the "Stonewall Guards" of Brookhaven, Mississippi, which was mustered into service in Jackson, Mississippi, on May 26, 1898. He was discharged on December 20, 1898. Ewing married Virginia Dosh. They had two sons and two daughters. He died on April 8, 1942. (Courtesy of the author.)

Merry E. Gibson was born in Mississippi, the middle child of Randol and Mary Gibson. He enlisted in the Army during the Spanish-American War on April 27, 1898, and served in the 1st Mississippi Volunteer Infantry, Company A, the "Volunteer Southrons" from Vicksburg. He died four months later on August 24, 1898, of pneumonia. Gibson was the first casualty of the Spanish-American War interred in Vicksburg National Cemetery. (Courtesy of the author.)

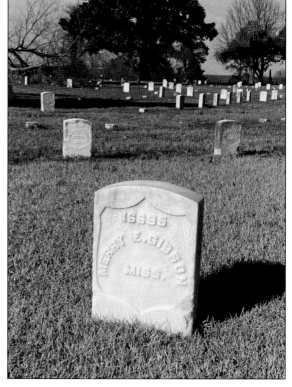

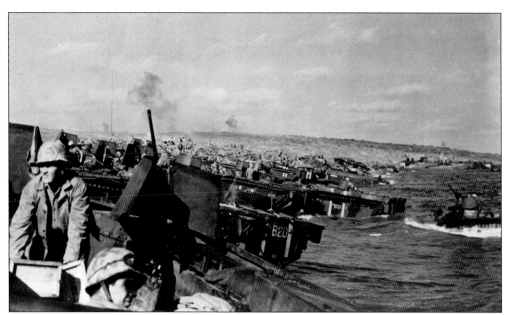

Otis Charles Gilbert, born on November 28, 1925, to Otis and Mable Gilbert in Carville, Louisiana, was the oldest of four children. Two days after his 18th birthday, on November 30, 1943, Gilbert completed his World War II draft registration in Stoneville, Mississippi. Private First Class Gilbert served in the 4th Marine Division, 24th Marine Regiment, 2nd Battalion, Company F. Pfc. Otis Charles Gilbert was killed on Iwo Jima on March 1, 1945, at 19 years of age and was posthumously awarded the Purple Heart. Above, landing craft transport Gilbert's Marine division and the 5th Marine Division to the assault beach at Iwo Jima. (Above, courtesy of NARA; below, courtesy of the author.)

Cpl. Champ Gully Gillespie served in both World War II and the Korean War. Born on March 7, 1918, in Preston, Mississippi, to Neal and Mamie Glispie, he married Virdie Bell Welch in August 1949. At one time, the couple lived in De Kalb, Mississippi. They had a son named Winford. During World War II, Corporal Gillespie served in the Army Air Corps. Gillespie served in the 2nd Infantry Division, 503rd Field Artillery Battalion, during the Korean War. This photograph of the Korean War Memorial in Washington, DC, depicts soldiers on patrol in the rice paddies of Korea. Gillespie was killed while in combat in North Korea on December 1, 1950, at 33. He was posthumously awarded the Purple Heart. His other awards included the Korean Service Medal, the United Nations Service Medal, the National Defense Service Medal, the Korean Presidential Unit Citation, and the Republic of Korea War Service Medal. (Courtesy of LOC.)

Born in 1897 in New Orleans, Louisiana, to Thomas J. and Ida (McEckron) Harvey, YN2 Mary Catherine Harvey Guido served in the US Navy during World War I in the 8th Naval District, Company F, nicknamed "Yeomanettes." In this role, the women yeomen, seen in the above photograph, mainly fulfilled clerical and secretarial duties; however, some became translators, draftsmen, and fingerprint experts. Guido served her country from April 25, 1918, to July 29, 1919. She married Matthew Lawrence Guido, who was also a World War I veteran, and the two had a son named Matthew Lawrence Guido Jr. He was born on March 10, 1928, and she died on March 19, 1928, of nephritis nine days after the birth of their son. (Above, courtesy of NHHC; right, courtesy of the author.)

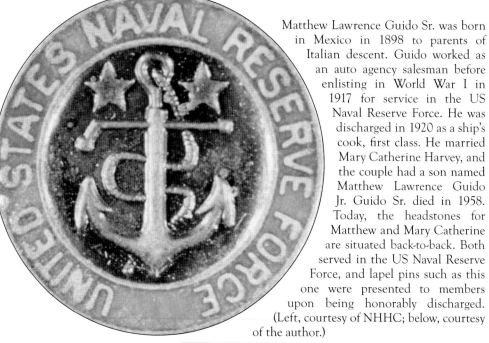

Matthew Lawrence Guido Sr. was born in Mexico in 1898 to parents of Italian descent. Guido worked as an auto agency salesman before enlisting in World War I in 1917 for service in the US Naval Reserve Force. He was discharged in 1920 as a ship's cook, first class. He married Mary Catherine Harvey, and the couple had a son named Matthew Lawrence Guido Jr. Guido Sr. died in 1958. Today, the headstones for Matthew and Mary Catherine are situated back-to-back. Both served in the US Naval Reserve Force, and lapel pins such as this one were presented to members upon being honorably discharged. (Left, courtesy of NHHC; below, courtesy of the author.)

Edgar Horace Hawter, born in Western Australia, served in the Royal Australian Air Force (RAAF) as a flight sergeant in World War II. On July 26, 1942, Hawter was copiloting the B-25C Mitchell bomber nicknamed "Aurora" on a mission off the coast of Gasmata, Papua New Guinea, when the plane was shot down. Hawter and three other crew members were killed. The remains of three of the four victims were found inside the wreckage, but the plane was in enemy territory and not recovered until 1943. In 1949, Hawter, Vernon McBroom, and Robert T. Middleton were interred together in the cemetery. Initially, one headstone for all three was erected. In the early 2000s, a headstone from Australia for Hawter was placed beside the original. (Right, courtesy of the National Archives of Australia, NAA: A9301, 406129; below, courtesy of the author.)

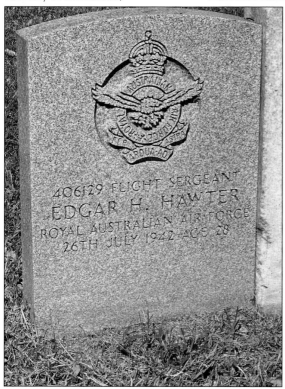

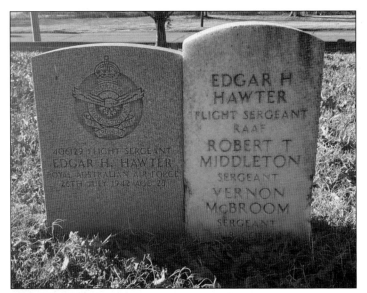

In December 1949, it was discovered that RAAF flight sergeant Edgar Horace Hawter's remains were brought to the United States for burial in Vicksburg National Cemetery along with those of Vicksburg natives Sgts. Vernon McBroom and Robert Thomas Middleton. Hawter's relatives were consulted and agreed to let him rest where he remains. Hawter is the only foreign soldier buried in the cemetery. (Courtesy of the author.)

An aerial photograph taken during World War II shows a B-25 Mitchell bomber flying over bombing targets. RAAF flight sergeant Edgar Horace Hawter served as copilot of the B-25C bomber nicknamed "Aurora" as part of the Allied Forces. On July 26, 1942, Hawter became one of the 3,486 Royal Australian Air Force casualties when the plane he was copiloting was shot down. (Courtesy of NARA.)

Born on July 29, 1920, to Gertie M. and George W. Irving, Wellington Generette Irving hailed from Belzoni, Mississippi. During World War II, he graduated in the 43-K-SE Class, seen below, from flight training at Tuskegee Army Airfield in Alabama on December 5, 1943, with the rank of second lieutenant. African American pilots were given the nickname "Tuskegee Airmen." Only 10 were from Mississippi. Irving was deployed to Italy in 1944 and served in the 332nd Fighter Group, 301st Fighter Squadron, as a pilot with the US Army Air Corps. On July 18, 1944, while engaged in aerial warfare, 2nd Lt. Wellington Irving was killed in action, becoming Mississippi's first black World War II military aviator killed in combat. (Both, courtesy of US Air Force Historical Research Agency, Maxwell Air Force Base.)

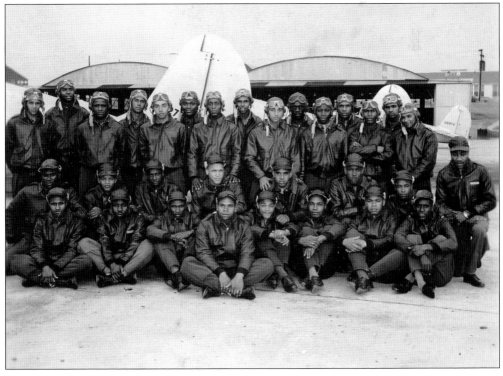

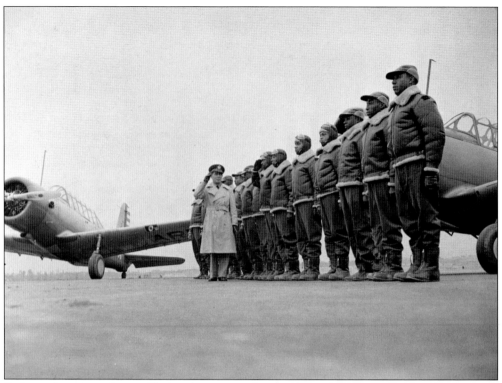

Tuskegee Airmen, nicknamed by bomber crews as "Red Tail Angels" due to the red tail markings on their airplanes, are lined up for review and inspection by Maj. James A. Ellison on January 23, 1942, while undergoing training at Tuskegee Army Airfield in Tuskegee, Alabama. Irving graduated on December 5, 1943. The 332nd flew successful missions over Sicily, the Mediterranean, and North Africa. A Distinguished Unit Citation was presented to the 332nd Fighter Group for "outstanding performance and extraordinary heroism." Below, a group of Army Air Corps cadets pauses for a photograph while undergoing training at Tuskegee Army Air Field. (Both, courtesy of LOC.)

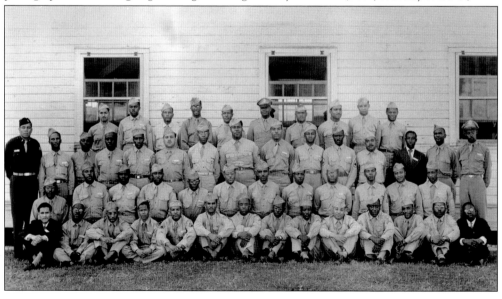

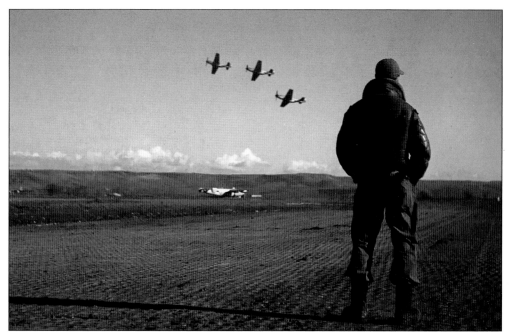

During World War II, Tuskegee Airmen flew a total of 1,500 missions, during which they destroyed over 260 enemy aircraft. Above, an unidentified airman watches planes flying at an airfield in Ramatelli, Italy. Below is a close-up view of a restored P-51 Mustang on display by the Commemorative Air Force to honor the brave Tuskegee Airmen of World War II. 2nd Lt. Wellington G. Irving was the pilot of a P-51C Mustang. On July 18, 1944, Irving, along with other members of the 332nd, was on a mission to escort bombers of the 5th Wing to Memmingen airdrome when it was attacked. Irving was last seen by his wingman, Lt. Stanley L. Harris, as he dove down on German fighter planes. His body was never recovered. A memorial headstone was placed by his family in the cemetery. (Above, courtesy of LOC; below, courtesy of the author.)

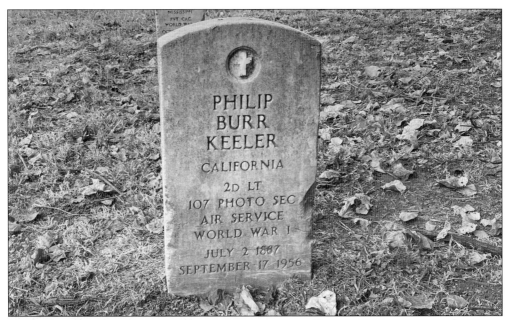

Philip Burr Keeler was born on July 2, 1887, in Kewanee, Illinois, to Mary Frances Whittemore and Philip Burr Keeler. On February 5, 1910, he married Carolyn Belle Breed in Rock Island, Illinois. In 1917, he was 30, married with two sons, and working as a traveling demonstrator for Ausco Company when he completed his draft registration in Palo Alto, California, on June 5. During World War I, Second Lieutenant Keeler served in the 107th Photographic Section Air Service conducting aerial reconnaissance photography using a camera much like the one below, which would have been installed in the plane's fuselage. He died at 69 in 1956 and is interred in Vicksburg National Cemetery. Carolyn died in 1974 at 82 and is buried in Westlawn-Hillcrest Memorial Park in Omaha, Nebraska. (Above, courtesy of the author; below, courtesy of NARA.)

Aerial reconnaissance photography began as early as 1911 and was initially used at low altitudes with the photographer pointing the camera at a downward angle so as to capture the best photographs. The cameras were installed inside of the plane's fuselage, just rear of the cockpit and toward the tail. Cameras would point out of the right side of the aircraft through a hole cut in the canvas toward the bottom. It was positioned so as not to project through the canvas. Shown at right is the location where a camera was to be installed. Much like the below unidentified World War I aerial reconnaissance photographer, Keeler would have positioned his camera through the opening in preparation for shooting oblique aerial photographs. (Both, courtesy of NARA.)

Pfc. Henry Lee Keen was born on August 31, 1925, in Braxton, Mississippi, to Edith Aileen Harper (later Hines) and Patrick Henry Keen. While living and working in Dearborn, Michigan, Keen enlisted in the US Marine Corps in 1943 at 18. He was assigned to the Fleet Marine Force, 5th Marine Division, 28th Marine Regiment, 2nd Battalion, Company D, as a rifleman. At left, Keen is in uniform with a marksmanship badge attached to his left breast pocket. Below, Keen is pictured following basic training at Camp Pendleton, San Diego, California, while home on furlough in Mississippi and before being shipped overseas. (Both, courtesy of Mississippi Armed Forces Museum.)

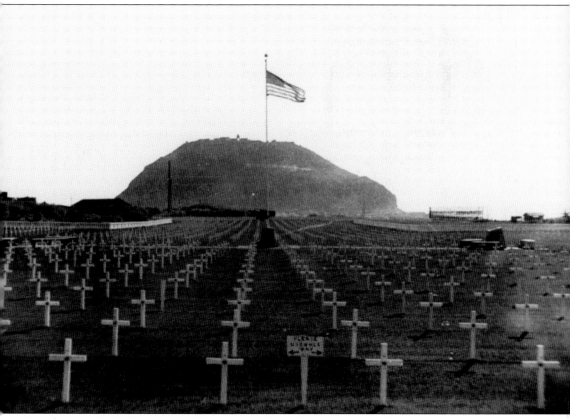

On February 19, 1945, Keen and his company landed on Green Beach 1 on Iwo Jima among intense enemy fire, and the battle raged on. Mount Suribachi was captured, and the American flag was planted at the top signaling its successful capture on February 23, 1945 (there were two flags planted, a smaller flag at first, which was replaced by a larger flag so all below could see). After conquering Mount Suribachi, Keen and his company were allowed a few days' rest, and Keen wrote his mother the following letter, dated February 25, 1945: "Dearest Mother I know you are worried about not hearing from us within the past 6 or 7 weeks. . . . Mom, I am writing at the base of the hill we have captured which was a day or two ago." Six Marines of the 28th Marines, 2nd Battalion, planted the flag atop Mount Suribachi on Iwo Jima, captured in the iconic photograph by Associated Press photographer Joe Rosenthal. On March 11, 1945, Keen was shot while making an advance and died of his wounds a short time later. He was originally buried in Iwo Jima 5th Marine Division Cemetery, pictured, situated below Mount Suribachi. (Courtesy of Mississippi Armed Forces Museum.)

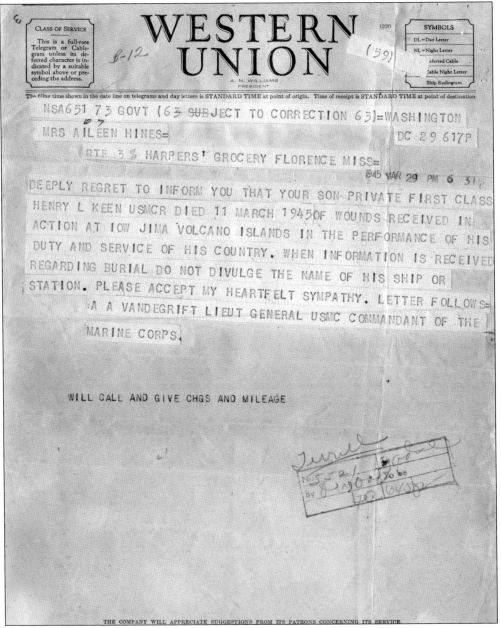

CLASS OF SERVICE

This is a full-rate Telegram or Cablegram unless its deferred character is indicated by a suitable symbol above or preceding the address.

WESTERN UNION

A. N. WILLIAMS
PRESIDENT

1220

SYMBOLS

DL = Day Letter

NL = Night Letter

Deferred Cable

Cable Night Letter

Ship Radiogram

The filing time shown in the date line on telegrams and day letters is STANDARD TIME at point of origin. Time of receipt is STANDARD TIME at point of destination

NSA651 73 GOVT (63 SUBJECT TO CORRECTION 63)=WASHINGTON

MRS AILEEN HINES= DC 29 617P

RTF 3% HARPERS' GROCERY FLORENCE MISS=

1945 MAR 29 PM 6 31

DEEPLY REGRET TO INFORM YOU THAT YOUR SON PRIVATE FIRST CLASS HENRY L KEEN USMCR DIED 11 MARCH 1945OF WOUNDS RECEIVED IN ACTION AT IOW JIMA VOLCANO ISLANDS IN THE PERFORMANCE OF HIS DUTY AND SERVICE OF HIS COUNTRY. WHEN INFORMATION IS RECEIVED REGARDING BURIAL DO NOT DIVULGE THE NAME OF HIS SHIP OR STATION. PLEASE ACCEPT MY HEARTFELT SYMPATHY. LETTER FOLLOWS= A A VANDEGRIFT LIEUT GENERAL USMC COMMANDANT OF THE MARINE CORPS.

WILL CALL AND GIVE CHGS AND MILEAGE

THE COMPANY WILL APPRECIATE SUGGESTIONS FROM ITS PATRONS CONCERNING ITS SERVICE

This Western Union telegram was sent to Aileen Hines in Florence, Mississippi, notifying her of Pfc. Henry Lee Keen's death. The telegraph briefly describes the circumstances and date of his death. In a letter dated May 1945, written by 1st Lt. Harold George Shrier (one of the first Mount Suribachi flag raisers) with the 5th Marine Division, 28th Marine Regiment, 2nd Battalion, Company D, he expresses his sympathy for the death of Pfc. Henry Lee Keen. He further wrote, "Of all the men in the company who lived served together there was no one who was more highly respected. He was always an example of courage and inspiration to the men of the company. . . . Henry was wounded on March 11th and died shortly thereafter. . . . He was hit by rifle fire while making an advance. He was buried March 13th in the 5th Division Cemetery on Iwo Jima." (Courtesy of Mississippi Armed Forces Museum.)

Ridgely Casey Lilly Civil Engineering
JACKSBORO, TEXAS

Member Austin Literary Society; Senior Tennis Club; The Bats.

R. C. has left our hospitable shores several times, but like the prodigal, has always returned. One of "Batwright's Best." Sometimes calls himself "R The," but this should fool no one, as he and R. C. Lilly are identically the same person.

Ridgely Casey Lilly was born on October 1, 1884, in Palo Pinto, Texas, to Alice Elizabeth Casey and James Ridgely Lilly. In 1907, Lilly graduated from Texas A&M with a degree in civil engineering, and this photograph appeared in the 1907 *Long Horn* annual. On May 1, 1917, he married Marie Eva Richoux Heriard in Desha, Arkansas. The two were married for 13 years until his death. During World War I, he was called for active duty in the Army on July 10, 1917, and served as first lieutenant in the 312th Engineers Company and later 2nd Engineers Company until his discharge. He served overseas from September 12, 1917, to August 9, 1919, serving in the following engagements in France: Champagne, St. Mihiel, Oise-Aisne, and Meuse-Argonne. He was promoted to captain on August 29, 1918, and honorably discharged on August 29, 1919. (Courtesy of Cushing Memorial Library & Archives, Texas A&M University.)

At the time of Ridgely Lilly's death, he and his wife were living on Washington Street in Vicksburg. He died of pneumonia on August 5, 1930, at 45. An intricately designed upright shaft monument marks his grave featuring "Lilly" written on the base and a cross etched from the stone with a flower at its base. It is one of the few personal cemetery markers found within Vicksburg National Cemetery. (Courtesy of the author.)

Erected by Vicksburg Veterans of Foreign Wars Post 2572 in May 1986, the Warren County War Memorial, located within the Rose Garden in downtown Vicksburg, honors the memory of those from Warren County who paid the ultimate sacrifice for their country during World War I, World War II, and the Korean War. (Courtesy of the author.)

Sgt. Vernon McBroom was born in Warren County in 1917. He served in the US Army Air Corps as an airplane mechanic in World War II. On the morning of July 26, 1942, McBroom was killed when the six-man crew of his B-25C Mitchell bomber, nicknamed "Aurora," was hit by gunfire. Only two of the six were able to deploy parachutes. The remains of three of the four victims were found inside the wreckage, but since the plane was in enemy territory, it was not recovered until 1943. The remains of McBroom, Robert T. Middleton, and Edgar Horace Hawter of the RAAF are interred together at Vicksburg National Cemetery. The Warren County War Memorial honors those from Vicksburg who paid the ultimate sacrifice for their country. Below, McBroom's name is included on the memorial. (Both, courtesy of the author.)

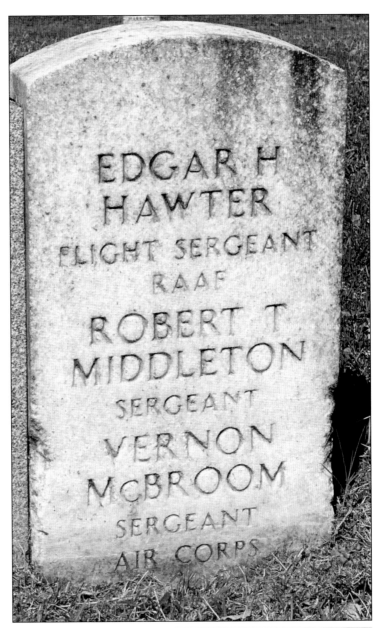

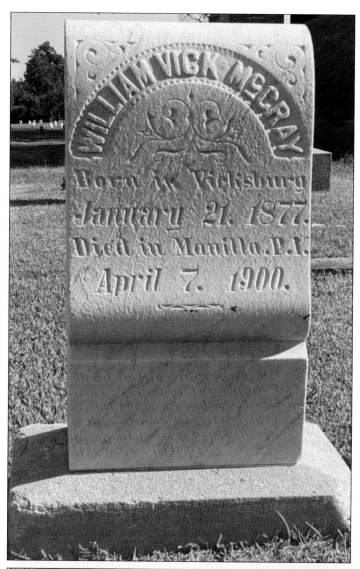

Born in Vicksburg on January 21, 1877, William Vick McCray is a Vick family descendant; his paternal grandmother, Matilda Louisa Vick, was the daughter of Vicksburg's founder, Rev. Newitt Vick. McCray fought in the Philippine-American War, also known as the Philippine Insurrection. According to pension records, he served in the 11th US Volunteer Cavalry Regiment, Company G. He died in Manila, Capital District, National Capital Region, Philippines, on April 7, 1900. He was 23 years old. William Vick McCray Jr. was the brother-in-law of cemetery superintendent Thomas O'Shea. Below, the epitaph on the marker reads, "Dead in life's morning yet. / Were every one for whom he / did a loving kindness, to bring / a blossom to his grave tonight / he would sleep beneath a / wilderness of flowers." (Both, courtesy of the author.)

S.Sgt. Noble Mayfield McMillin was born in Newellton, Louisiana, on August 30, 1919, to Gertrude Varner and Bennie McMillin. He had three siblings. The family lived on a farm in Warren County. During World War II, he served in the 1st Coast Artillery, Battery H, and was stationed at Fort Sherman, above, named for Gen. William Tecumseh Sherman. He served in the Army from 1937 to 1940 in the Panama Canal Zone. In 1941, he re-enlisted, serving in the US Army Ordnance Department. He died on May 15, 1942, of unspecified non-battle causes at 22. Below is his name as it appears on the Warren County War Memorial in the downtown Vicksburg Rose Garden. (Above, courtesy of LOC; below, courtesy of the author.)

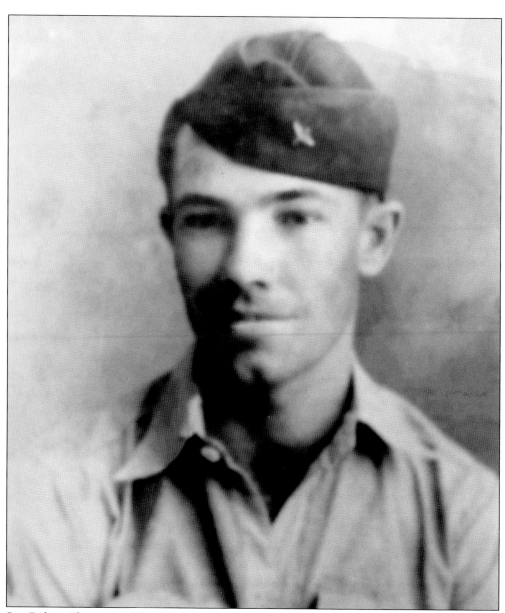

Sgt. Robert Thomas Middleton was born on July 26, 1921, in Vicksburg, Mississippi. He served in the US Army Air Corps as a bombardier in World War II. On the morning of July 26, 1942, Middleton was killed when the six-man crew of his B-25C Mitchell bomber was hit by gunfire. Only two of the six were able to deploy parachutes. The remains of Middleton, Vernon McBroom, and Edgar Horace Hawter were found inside the wreckage and recovered in 1943. The three men are interred together at Vicksburg National Cemetery. Below, Middleton's name is seen on the Warren County War Memorial. (Above, courtesy of Beverly Haun; below, courtesy of the author.)

ROBERT T. MIDDLETON

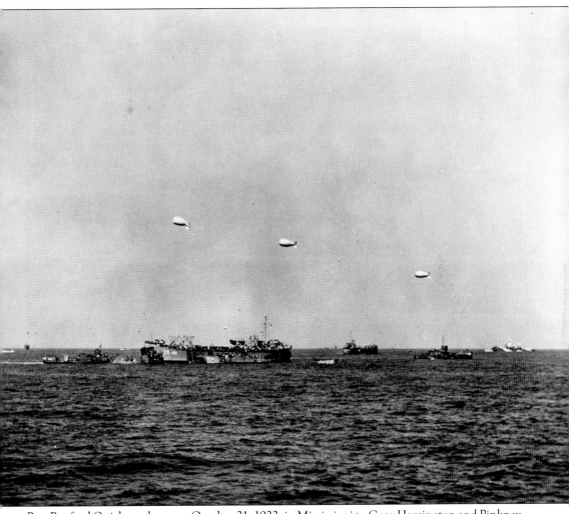

Pvt. Rayford Quick was born on October 21, 1922, in Mississippi to Cora Herrington and Pinkney Cleveland Quick. Before his Army enlistment, Quick was working as a farmhand. He enlisted at Camp Shelby in Hattiesburg, Mississippi, on March 2, 1943, and was assigned to Company K of the 22nd Infantry in the 4th Infantry Division. Quick's company became part of the 3rd Battalion of the 22nd Infantry. On June 6, 1944, known as D-Day, the 3rd Battalion, attached to the 8th Infantry, was assigned to Utah Beach of the Normandy landings. The 3rd Battalion made its way toward the shore, as in this photograph showing landing craft approaching in preparation for landing off of Utah Beach. On July 11, Quick's battalion was ordered to assault high ground near Raids, France. Private Quick was killed that day. He was 22. In 1949, Quick's remains were repatriated to the United States. He was reinterred in Vicksburg National Cemetery on April 1, 1949. (Courtesy of NHHC.)

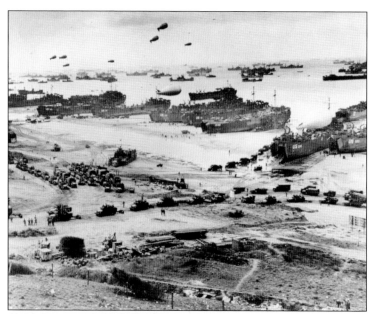

Utilizing the combined land, air, and sea forces of the Allied troops, D-Day became the largest amphibious invasion in military history to date. Landing craft, barrage balloons, and Allied troops landed on the beaches of Normandy, France, on June 6, 1944. The operation was assigned the codename Overlord. (Courtesy of LOC.)

Of all the Normandy beach landings on D-Day, Utah Beach, where Pvt. Rayford Quick and the 4th Division stormed, was considered an American success due to the achievement of the surprise factor, their quick movement inland, and the low number of casualties that followed. This view is of one of the beaches of Normandy. (Courtesy of Peggy Gouras.)

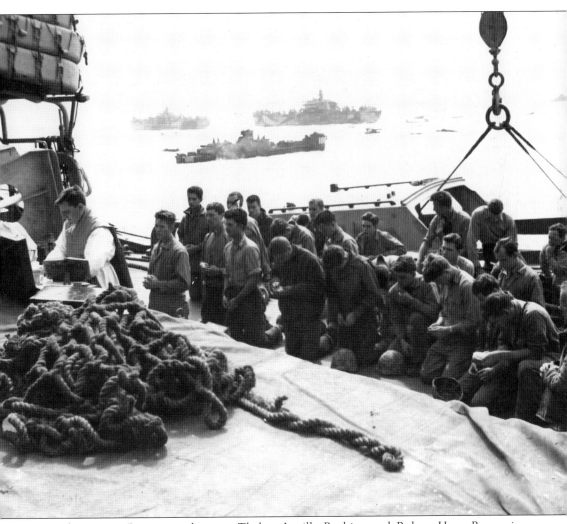

Sgt. Robert Hope Rogers was born to Thelma Lucille Rushing and Robert Hope Rogers in Hattiesburg, Mississippi, on October 12, 1925. When he was only four, his mother died, and the family moved in with his maternal grandparents. His father was a World War I veteran. Rogers Jr. enlisted in the US Marine Corps in Shreveport, Louisiana. He served from 1941 to 1945 in the Fleet Marine Force, 4th Marine Division, 25th Marines, 1st Battalion, C Company, as a noncommissioned officer in the 737th Rifle Company. Rogers was killed on March 1, 1945, during the Battle of Iwo Jima, waged from February 19 to March 26, 1945, in which a total of 6,140 Marines were killed. This photograph shows the 4th Marine Division taking part in a Catholic mass before their landing on the island of Iwo Jima. Rogers was 19. Among the decorations awarded posthumously were the Navy Presidential Unit Citation and the Purple Heart with Gold Star. His remains were repatriated for burial at Vicksburg National Cemetery in April 1949. (Courtesy of NHHC.)

Season's Greetings

Born on August 22, 1921, Louis Spencer Jr. served in the Navy during World War II as a steward's mate first class petty officer. Spencer, second from the right, was an original member of the popular Vicksburg band the Red Tops, in which he played saxophone for 20 years. He served as chief messenger for the US Army Corps of Engineers for 37 years. Other entrepreneurial pursuits included working at the Saenger Theatre in Vicksburg, operating Gladys' Grocery Store, and owning and managing a janitorial service. He was a member of Mount Heroden Baptist Church and a charter member of the American Legion Tyner Post No. 213. Spencer died on August 20, 2010, at 88 years of age. His father, Louis Spencer Sr., who served in World War I, as well as his wife, Willie Mae Spencer, are also interred at Vicksburg National Cemetery. (Courtesy of Nancy and James Harrison.)

Pfc. J.C. Upton Jr., from Bay Springs, Mississippi, enlisted in the Army on July 8, 1943, at Camp Shelby. During World War II, he served with the XVIII Corps (Airborne), 17th Airborne Division, 507th Parachute Infantry Regiment. On March 24, 1945, Upton's regiment was engaged in Operation Varsity and parachuted behind enemy lines in western Germany in support and advance of ground troops crossing the Rhine. Utilizing his light machine gun as he advanced, Upton fired at four tanks trained on US troops before running through heavy machine gun fire, hurling a grenade, and destroying a German tank. The remaining tanks retreated. His actions so inspired his fellow paratroopers that they continued to their objective with even more determination. Upton survived that day but died in a non-battle incident on May 18, 1945, at 23. For his valor and courageous actions, he was posthumously awarded the Distinguished Service Cross. In this image, US paratroopers wait for the order to jump during World War II. (Courtesy of LOC.)

Pfc. J.C. Upton was posthumously awarded the Distinguished Service Cross for his "extraordinary heroism in combat with an armed enemy force" that occurred on March 24, 1945. Accepting the decoration was Upton's father, R.L. Upton. The citation accompanying the decoration in part reads, "For extraordinary heroism in connection with military operations against an armed enemy on 24 March 1945 in the vicinity of Fluren, Germany." The Distinguished Service Cross was first established by Pres. Woodrow Wilson during World War I on January 2, 1918, at the recommendation of Gen. John J. Pershing, general-in-chief of the Expeditionary Forces in France. The Distinguished Service Cross is the Army's second-highest decoration for military personnel. Featured from left to right in this image are the Distinguished Service Cross, US 1st type, Distinguished Service Cross, US 2nd type, and the Distinguished Service Medal. (Courtesy of NARA.)

Four

Remembered with Honor and Respect
Vietnam War, 1955–1975

Emplaced beneath the shade of majestic magnolia trees and within view of the cemetery's imposing flagstaff, proudly flying the American flag, is the Memorial Section of Vicksburg National Cemetery. Park superintendent Daniel Lee declared this upper terrace as the Memorial Section in 1976. Within this section sit three marble memorials, one for each of the Vietnam War military personnel who are remembered with honor and respect. The first memorial to be dedicated was that of Col. Herbert Lamar Lunsford of the US Air Force in 1976. In 1994, another memorial was dedicated for Sgt. Billy Dare Clark of the US Army. Two years later, a memorial was dedicated for Maj. Walter Jeffrey Boler, who served in the US Air Force.

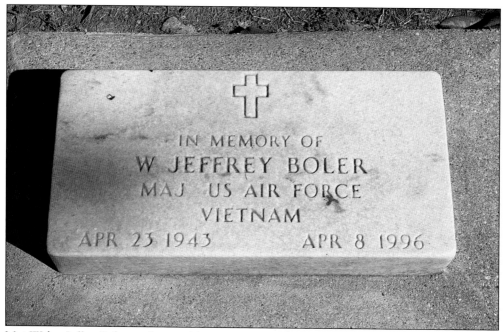

Maj. Walter Jeffrey Boler was born in Mississippi on April 23, 1943. During the Vietnam War, Boler served in the US Air Force. His postwar occupation was as an accounts manager for University Imaging in Hawaii. Boler had been a resident of Ewa Beach, Hawaii. He died of unknown causes on April 8, 1996, in Kaiser Hospital at 52. His ashes were scattered at sea. (Courtesy of the author.)

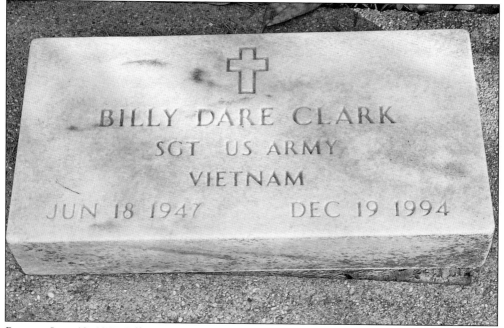

Born on June 18, 1947, Billy Dare Clark served in the US Army during the Vietnam War. During his military service, he attained the rank of sergeant. He married in October 1965 in Palm Beach, Florida. Clark died of unknown causes on December 19, 1994, at 47 years of age. (Courtesy of the author.)

Herbert Lamar Lunsford, born on September 2, 1928, to Rowena and William Lunsford, grew up in Meridian, Mississippi, graduating from Mississippi State University in 1952. He married Gwendolyn Franklin. The couple had three children. He joined the US Air Force, serving in the 7th Air Force, 366th Tactical Fighter Wing, 390th Tactical Fighter Squadron during the Vietnam War. (Courtesy of Reveille Collection, University Archives, Archives and Special Collections, MSU Libraries.)

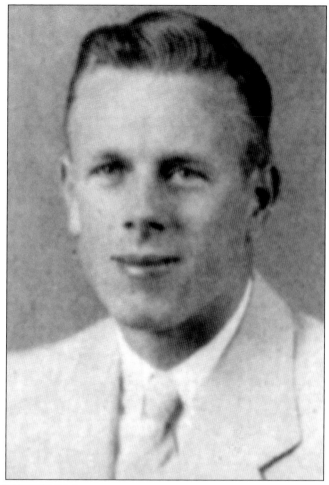

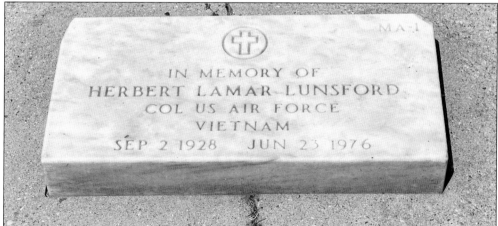

On July 25, 1967, Lunsford, piloting a McDonnell Douglas F-4C Phantom II fighter, and 1st Lt. Jeremy M. Jarvis were on a nighttime armed reconnaissance mission over North Vietnam when their plane was shot down and crashed. After an extensive search, they were declared missing in action. Lunsford was 38. Their remains were never recovered. (Courtesy of the author.)

This aerial view of the Port of Da Nang, Republic of Vietnam, was taken in October 1967. Colonel Lunsford was a member of the 390th Tactical Fighter Squadron, stationed at Da Nang Airbase, South Vietnam. He served as the pilot of a McDonnell Douglas F-4C Phantom II. Lunsford's aircraft was shot down on July 25, 1967. He was one of 636 from Mississippi who died during the Vietnam War. (Courtesy of NHHC.)

The F-4C was the US Air Force's first version of the Phantom II, which made its maiden flight in May 1963. It was widely used by pilots such as Lunsford during Vietnam because of its maneuverability at high and low altitudes. In this image, an F-4B Phantom fighter (precursor to F-4C) drops bombs on an artillery site north of a demilitarized zone in 1968. (Courtesy of NHHC.)

During the ground-breaking ceremony for the Vietnam Veterans Memorial in Washington, DC, a military color guard presents the colors in line formation before the area designated as the future location for the memorial. The American flag and the colors of each branch of the military are represented during the ceremony. A shovel and stake marker, adorned with ribbon, can be seen in the foreground. Among the names found on the wall is that of Col. Herbert Lamar Lunsford, honored on Panel 23E, Line 119. The memorial is composed of two adjoining walls. Each wall is 246 feet, 9 inches long and composed of 72 black polished granite panels engraved with the names of those service members who sacrificed their all or remain missing as a result of their service in Vietnam and Southeast Asia. Completed in 1982, the wall is the brainchild of Vietnam veteran Jan Scruggs. (Courtesy of LOC.)

After returning home from the Vietnam War, Jan Scruggs wanted to do something to honor and remember his fellow Vietnam veterans. He was inspired to create a memorial. It was his intention that the memorial would serve in the healing process for the nation and for Vietnam veterans. The memorial was to be a tribute to all who served. He put forth $2,800 toward this endeavor. He later gained the support of other Vietnam veterans in order to persuade Congress to provide a prominent location on federal land in Washington, DC, on which to erect such a memorial. The Vietnam Veterans Memorial Fund Inc., a nonprofit organization, was created with its mission to build and maintain the memorial. With Scruggs at the helm, the group raised $8.4 million. The ground-breaking ceremony, shown here, was attended by Vietnam, World War II, and Korean War veterans, as well as families of veterans who did not return from Vietnam. The memorial, located near the Lincoln Memorial on the National Mall, was dedicated on November 13, 1982. (Courtesy of LOC.)

Five

VICKSBURG NATIONAL CEMETERY SUPERINTENDENTS

GUARDIANS OF THIS HALLOWED GROUND

An act of Congress approved on February 22, 1867, entitled "An Act to Establish and to Protect National Cemeteries," provided criteria for the appointment of cemetery superintendents for all national cemeteries. Section 2 of the act further directed the secretary of war to appoint "a meritorious and trustworthy superintendent." Initially, candidates were selected from enlisted men who had served in the Army and were disabled during their service. Later, the act was widened to include the selection of noncommissioned officers or enlisted men who had been honorably discharged and who may have been disabled.

Superintendents were to reside in the cemetery in a lodge located at the entrance. Their main duties were to guard and protect the cemetery and to provide information to the visiting public. Other duties included ensuring that interments were properly conducted and the oversight and management of the cemetery. Interred within Vicksburg National Cemetery are four former cemetery superintendents.

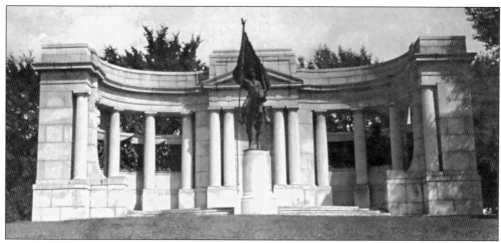

Alexander Henry was born in 1835. During the Civil War, Sergeant Henry served with the 24th Iowa, Company K. He was appointed Vicksburg National Cemetery's first superintendent in 1868. In 1871, he married Janette McGee Cathell, the widow of John Cathell, a former Confederate soldier who died in 1869. The Iowa Memorial, featuring six panels depicting the battles that comprised the Vicksburg campaign, is seen here. (Courtesy of VNMP.)

On May 16, 1863, Henry, with Company K of the 24th Iowa, fought at the Battle of Champion Hill near Edwards, Mississippi, as depicted in this panel featured on the Iowa State Memorial in Vicksburg National Military Park. Ironically, his wife's first husband's Confederate regiment was also engaged; he was wounded, captured, and sent to Camp Douglas in Illinois. (Courtesy of VNMP.)

By late August 1868, Alexander Henry had been appointed as the cemetery's first permanent superintendent. Henry reported for duty on September 9, but there was no appropriate housing available. Construction of the superintendent's lodge was begun, and by December's end, the work was completed and the house ready for occupancy as seen to the right of this photograph. Positioned near the main entrance to the cemetery, on the highest point located within Section O, was the original wooden flagstaff. During the afternoon of June 23, 1880, a thunderstorm occurred, during which time the flagstaff was destroyed by lightning. One month later, the erection of a new wooden flagstaff was authorized as a replacement. In 1906, a 100-foot iron flagstaff was erected in its place, and it remains today. The rostrum, which accommodated speakers during various events held in the cemetery, can be viewed to the right of the flagstaff. (Courtesy of the photograph collection of the Old Court House Museum.)

According to line No. 27 of the 1870 Vicksburg, Mississippi, census, Henry reported that he was born in Scotland. In a letter discovered after his death, he wrote that he was born in England. On January 19, 1871, Henry married Jennie McGee Cathell in Vicksburg. Jennie and Alexander had a son, Norman McLeod Henry, who became a dentist in Vicksburg. (Courtesy of NARA.)

This is the government-issued headstone of the cemetery's first superintendent, Alexander Henry, who died on April 22, 1885, at 50 years. After his passing, Jennie discovered a letter in which he revealed his real name was Henry Hamilton, he was born in England, and he had immigrated to the United States, changing his name to escape a murder charge. Jennie died in 1930 and is buried in Cedar Hill Cemetery in Vicksburg. (Courtesy of the author.)

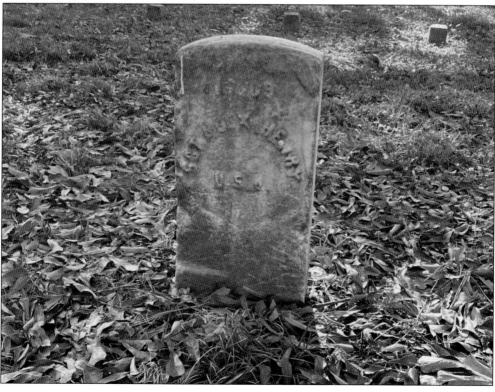

Born in Castlewellan, Ireland, in 1841, John Trindle immigrated to the United States and joined the Union army during the Civil War, serving in the 56th Massachusetts Infantry Regiment, Company K. Seen here is a copy of Trindle's compiled service record showing his rank as private. According to the company's muster roll, his dates of service are listed as February 29–August 31, 1864. (Courtesy of NARA.)

A camp is pictured in front of Petersburg, Virginia, in 1864. On July 21, 1864, while at Petersburg, Pvt. John Trindle was wounded, resulting in the loss of his left leg. He was later appointed the second superintendent of Vicksburg National Cemetery and worked for many years in that capacity. (Courtesy of LOC.)

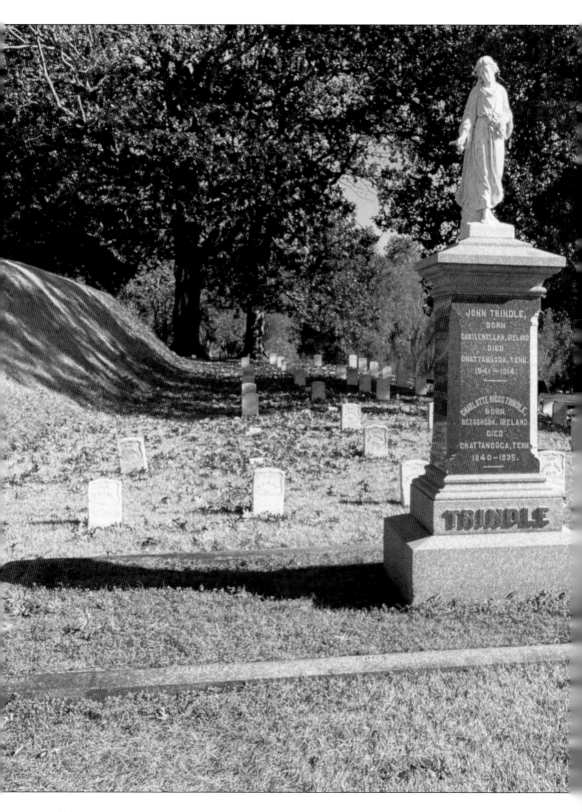

On the monument:

JOHN TRINDLE,
BORN
CASTLEWELLAN, IRELAND
DIED
CHATTANOOGA, TENN.
1841 – 1914

CHARLOTTE RIGGS TRINDLE,
BORN
BESSBROOK, IRELAND
DIED
CHATTANOOGA, TENN.
1840 – 1935.

TRINDLE

While at Vicksburg, John Trindle and his wife, Charlotte, lost their secondborn, Charlotte Mercer Trindle, who died in 1875 at three years. In 1878, the Trindles endured a yellow fever epidemic. He and his wife survived, but their remaining three children, William George, Margaret Belle, and Eola Maude, did not. John was given a transfer order in 1881 in which he was to move to Antietam, but due to the tragic loss of his family, he and his wife found it very difficult to leave. They were granted another year in Vicksburg. In 1882, he was given another transfer order in which he was moved to Chattanooga, Tennessee. He remained there until his death at 73 on February 13, 1914. Originally buried in Tennessee, he was reinterred in the cemetery with his wife and children. (Courtesy of the author.)

Pvt. Thomas O'Shea was born in Cork, Ireland, on July 14, 1859, and immigrated to America in 1879. During the Spanish-American War, O'Shea served with the 6th Cavalry. Seen here is the 6th US Cavalry, Troop I, training at Camp Tampa, Florida, in 1898. He married Eva McCray, daughter of William Vick McCray Sr. and Lucy McCray, on October 19, 1895, in Warren County, Mississippi. (Courtesy of LOC.)

As of this 1910 census (see last two lines), the O'Sheas had given birth to only one child, Catherine, who had lived to be barely one year old when she passed away in 1898. By the time that this census was taken, the couple was living in Rutherford, Tennessee. (Courtesy of NARA.)

Unique to all other markers found in the cemetery is that of Catherine O'Shea, daughter of Eva and Thomas O'Shea. Catherine was one month shy of her first birthday when she died. Born on August 22, 1897, she passed on July 24, 1898. Located in proximity to the cemetery marker of her uncle, William Vick McCray, brother of her mother, Eva, and steps away from her father, Thomas O'Shea's headstone, stands Catherine's marker. A single lamb, serving as a silent sentinel, rests atop the marker, representing innocence and purity. The marker is comprised of three segments. Located toward the bottom of the top segment is the epitaph etched in stone and written in Latin from Matthew 19:14: "Suffer little children to come unto me, and forbid them not: for of such is the Kingdom of God." (Courtesy of the author.)

The application must be in duplicate and accompanied by
by three inches in size, one of which is to be affixed to the p
application and its duplicate, respectively. The photographs
one not attached to the applications should be signed by the ap

☞ This blank must be completely
filled out. The legal fee of one dollar, in
currency or postal money order, and the
applicant's certificate of naturalization
must accompany the application.
The rules should be carefully read
before mailing the application to the De-
partment of State, Bureau of Citizen-
ship, Washington, D. C.

[Exect

[FORM FOR NAT

UNITED STATE

STATE OF _Texas_

COUNTY OF _Webb_ } ss:

I, _Thomas Shea_

THE UNITED STATES, hereby apply to the Departm

For myself and wife, - Eva Mc

at Vicksburg, Mississippi.

I solemnly swear that I was born at _Raha_

on or about the _____ 15th day

that I emigrated to the United States, sailing on b

from _Queenstown, Ireland_
(less 4-1/2 yrs. in U.S. service
that I resided _38_____ years, uninterrup
various stations and national c
at _as designed by War Department_

of the United States before the _Supreme_

at _Washington, D.C._

as shown by the accompanying Certificate of Natur

in said Certificate; that I am domiciled in the
wherever assigned by U.S. Governm
_Cemetery, Mexico-D.F._____ in the State of

occupation of _Supt. Natl. Cemetry_
_____ when ordere
intend to return to the United States xxxxx U.

residing and performing the duties of citizenship th

the countries hereinafter named for the following pu

United States of Mexico Ass
(Name of country.)

(Name of country.)

(Name of country.)

I intend to leave the United States from the

sailing on xxxxxxxx by train _____
(Name of vessel.)

OATH OF A

Further, I do solemnly swear that I will sup
States against all enemies, foreign and domestic; th
and that I take this obligation freely, without any
me God.

Sworn to before me this _13_

of _November_

[SEAL OF COURT.] L. C. M

Clerk of the _U.S._
[OVE

graphs of the applicant, not larger than three
ment; the other two must be attached to this
and should have a light background. The
so as not to obscure the features.

Issued 21 1917

No.

AMERICA.

TURALIZED AND LOYAL CITIZEN OF

ashington, for a passport.

rn August 5th, 1874,

ork, Ireland,

1, 859;

rd Line Samaria

June , 1879;

1 States, from 1879 to 1917.

at I was naturalized as a citizen

istrict of Columbia

ine 12th. 1 884,

the IDENTICAL PERSON described

permanent residence being XXX
t ordered to National

:, where I follow the
in the U.S. Service
to go abroad XXXXXXXXXX, and
f War
XXXXXX}
XXXXX } with the purpose of
re a passport for use in visiting

y by U.S. Government
of visit.)

d visit.)

of visit.)

Lo - Texas
(Port of departure.)

ecember, 14th
(Date of departure.)
1917

e Constitution of the United
h and allegiance to the same;
purpose of evasion: So help

Shea
gnature of applicant.)

In November 1917, Thomas O'Shea applied for a passport application for both he and Eva O'Shea, citing that he had been born in Rahalisk, County Cork, Ireland, and that he was a naturalized citizen of the United States, having resided here from 1879 through 1917. According to this application, he reported that he had spent approximately four and a half years in military service in Mexico. He recorded his occupation as national cemetery superintendent. At present, he was being ordered to the national cemetery in Mexico City, but they planned to return to the United States. O'Shea died on June 9, 1951, in St. Petersburg, Florida, at 92 years of age. He is interred in the cemetery. Eva O'Shea died on September 9, 1971, in Pinellas, Florida. (Courtesy of NARA.)

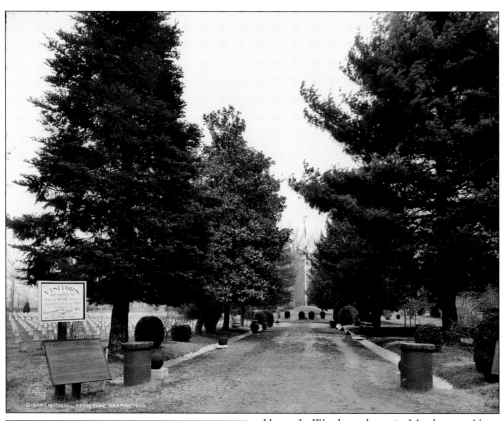

Henry L. Ward was born in Manhattan, New York City, in 1847. He served in the Civil War. Ward married Elizabeth C. Taylor and spent a number of years in what was then the Dakota Territory, where three of their children were born. Later, he was appointed cemetery superintendent at Fayetteville National Cemetery, where a fourth child was born, before serving at Memphis National Cemetery, seen here. (Courtesy of LOC.)

In 1882, Ward was ordered to Vicksburg. According to the 1880 census, Ward and his family were living in Shelby, Tennessee, when the census was conducted. He had only been at Vicksburg a short time when he died suddenly of what was surmised to be a stroke on November 12, 1883, at 35 years of age. (Courtesy of NARA.)

124

BURIAL INDEX

NAME	PAGE	BURIAL SITE
Anderson, Nelson A.	22	Section M, Grave No. 16863
Anderson, William Martin	70–71	Section W, Grave No. 17567
Arrieux, Numa	22	Section O, Grave No. 7101
Babcock, Jesse	23	Section G, Grave No. 4356
Bair, Cyrus H.	24	Section O, Grave No. 3673
Baker, Jacob M.	24	Section O, Grave No. 4296
Barnett, William Benjamin	72	Section W, Grave No. 17470
Bartley, Charles Horace Jr.	73	Section V, Grave No. 17574
Benner, Della G.	25	Section F, Grave No. 16595A
Benner, Hiram Harting	25	Section F, Grave No. 16595
Beyers, Robert E. Lee	74	Section G, Grave No. 5503A
Blake, Francis O.	26	Section H, Grave No. 590
Blanch, Philip	27	Section M, Grave No. 16664
Bockus, George Henry (Backus)	23	Section O, Grave No. 3523
Boessling, Ernst A.	28	Section F, Grave No. 1236
Boler, Walter Jeffrey	108	Memorial Section
Bonaparte, Napoleon	28	Section M, Grave No. 16673
Boyer, G.M. (Boyes)	29	Section O, Grave No. 3486
Brantley, Charles B.	30	Section B, Grave No. 2673
Brewer, William	30	Section E, Grave No. 1834
Brown, George W.	31	Section M, Grave No. 16678
Brown, Isaac S.	32	Section G, Grave No. 4947
Bryant, Edward	75	Section M, Grave No. 17115
Bullen, Robert Whitefield	76	Section G, Grave No. 4911
Bury, John J.	33	Section F, Grave No. 1238
Charleston, Sam Jr.	77	Section X, Grave No. 17615
Clark, Billy Dare	108	Memorial Section
Cobb, Isaac W.	34	Section D, Grave No. 2080
Cook, Edward J.	35	Section O, Grave No. 4273
Cook, Sylvanus Swain Sr.	36	Section C, Grave No. 2303
Cox, Joseph	36	Section L, Grave No. 6284
Crawford, Horace	37	Section I, Grave No. 8030
Crawford, Isaac	37	Section I, Grave No. 8029
Darracott, William Walker	79	Section G, Grave No. 7051B
Davis, Frederick E.	38	Section Q, Grave No. 9595

Name	Page	Burial Site
Davis, James H.	39	Section G, Grave No. 4858
Davis, Philip	40–41	Section M, Grave No. 11761
Elledge, J.H.	41	Section F, Grave No. 747
Ellis, Richard	42	Section O, Grave No. 4255
Ewing, Daniel Deúnett	80	Section O, Grave No. 3466A
Eyman, Edward C.	43	Section A, Grave No. 2964
Figi, Michael	44	Section G, Grave No. 4552
Flood, Eli	44	Section Q, Grave No. 9285
Gaiters, Anthony	45	Section V, Grave No. 17181
Gibson, Merry E.	80	Section G, Grave No. 16695
Gilbert, Otis Charles	81	Section W, Grave No. 17469
Gillespie, Champ Gully	82	Section X, Grave No. 17803
Green, George	46	Section L, Grave No. 16776
Guido, Mary Catherine	83	Section W, opposite Matthew Guido
Guido, Matthew Lawrence Sr.	84	Section W, Grave No. 17890
Hart, Henry William	46	Section A, Grave No. 3117
Hawter, Edgar Horace	85–86	Section W, Grave No. 17527
Henry, Alexander	114–116	Section R, Grave No. 16609
Hostetler, Eli	47	Section Q, Grave No. 9369
Howe, James Cassius	47	Section I, Grave No. 7392
Irving, Wellington Generette	87–89	Section X, Grave No. 17547
Jackson, John	48	Section M, Grave No. 17087
Keeler, Philip Burr	90–91	Section W, Grave No. 17830
Keen, Henry Lee	92–94	Section W, Grave No. 17416
Kempf, John	49	Section I, Grave No. 7458
Lewis, Edward	50	Section G, Grave No. 4892
Lilly, Ridgely Casey	95–96	Section L, Grave No. 6562B
Lounsberry, George	50	Section E, Grave No. 1718
Lunsford, Herbert Lamar	109–112	Memorial Section
Luther, Alfred J.	51	Section K, Grave No. 5971
McBroom, Vernon	97	Section W, Grave No. 17527
McCray, William Vick	98	Section G, Grave No. 16726
McMillin, Noble Mayfield	99	Section G, Grave No. 5598-B
Middleton, Robert Thomas	100	Section W, Grave No. 17527-29
Mitchell, Andrew	52	Section M, Grave No. 16820
Neely, William	52	Section E, Grave No. 1513
Nesmith, William W.	53	Section L, Grave No. 6498-A
Nussbaum, Benjamin Franklin	53	Section G, Grave No. 4981
Osband, Embury Durfee	54	Section O, Grave No. 16648
O'Shea, Catherine	121	Section G, Grave No. 16692
O'Shea, Thomas	120–123	Section G, Grave No. 17606
Pumplin, William L.H.	55	Section G, Grave No. 5253
Quick, Rayford	101–102	Section W, Grave No. 17494
Rigby, Eva Cattron	56	Section L, Grave No. 6050A
Rigby, William Titus	55–56	Section L, Grave No. 6050B
Robb, Lizzie	57	Section C, Grave No. 2305
Roby, Abraham	58	Section R, Grave No. 10274
Rogers, Robert Hope Jr.	103	Section W, Grave No. 17495
Rosenberger, Joseph	59	Section H, Grave No. 1
Sellers, James	59	Section G, Grave No. 4540

Name	Page	Burial Site
Shell, Edward H.	60	Section L, Grave No. 6529c
Skelton, Robert T.	60	Section O, Grave No. 3819
Slade, James Bog	61	Section O, Grave No. 3492a
Spencer, Louis Jr.	104	Section M, Grave No. 18044
Spencer, Louis Sr.	104	Section M, Grave No. 17340
Spencer, Willie Mae	104	Section M, Grave No. 18044-B
Squire, Harlan A.	62	Section G, Grave No. 5245
Stone, Marble F.	62	Section A, Grave No. 2983
St. Pierre, Xavier	63	Section O, Grave No. 7086
Summers, John	63	Section G, Grave No. 4652
Tollinger, Edward	64	Section L, Grave No. 6517-A
Trindle family	118–119	Section G Grave No. 16603A-16606
Trindle, John	117–119	Section G, Grave No. 16605
Turner, Asbury	65	Section O, Grave No. 3803
Upton, J.C. Jr.	105–106	Section W, Grave No. 17435
Vance, King	65	Section M, Grave No. 12829
W., F. (F.W.)	66	Section C, Grave No. 2334
Walsh, Patrick	66	Section P, Grave No. 10098
Ward, Henry	124	Section C, Grave No. 6229
White, Reuben Henry	67	Section B, Grave No. 2637

DISCOVER THOUSANDS OF LOCAL HISTORY BOOKS FEATURING MILLIONS OF VINTAGE IMAGES

Arcadia Publishing, the leading local history publisher in the United States, is committed to making history accessible and meaningful through publishing books that celebrate and preserve the heritage of America's people and places.

Find more books like this at
www.arcadiapublishing.com

Search for your hometown history, your old stomping grounds, and even your favorite sports team.

Consistent with our mission to preserve history on a local level, this book was printed in South Carolina on American-made paper and manufactured entirely in the United States. Products carrying the accredited Forest Stewardship Council (FSC) label are printed on 100 percent FSC-certified paper.

MADE IN THE USA